G000241784

HAMPSHIRE'S MILITARY HERITAGE

Dean Hollands

AMBERLEY

This book is dedicated to the memory of all those whose actions and deeds have created Hampshire's military heritage and to those who seek to preserve it.

First published 2018

Amberley Publishing
The Hill, Stroud
Gloucestershire, GL5 4EP

www.amberley-books.com

Copyright © Dean Hollands, 2018

Logo source material courtesy of Gerry van Tonder

The right of Dean Hollands to be identified as the Author of this work has been asserted in accordance with the Copyrights, Designs and Patents Act 1988.

ISBN 978 1 4456 8091 0 (print)
ISBN 978 1 4456 8092 7 (ebook)

British Library Cataloguing in Publication Data.
A catalogue record for this book is available from the British Library.

Origination by Amberley Publishing.
Printed in Great Britain.

Contents

Introduction

From the first Celtic invasion in around 480 BC to more recent conflicts in the Middle East and Afghanistan, Hampshire's military heritage is as diverse as it is ancient. During its darkest days the county, its airspace and its coastline have experienced many military conflicts that have turned its soil and sea red with the blood of invaders, defenders and civilians alike.

Throughout its history Hampshire's coastal defences have repelled aggressors while its ports have played a vital role in defending the realm, the empire, its allies and others against invasion, tyranny and terrorism. Its airfields have been used to defend national airspace and support ground force operations of the twentieth and twenty-first centuries.

Many of the county's prisons, castles, forts, barracks, ships and villages were used to detain and accommodate prisoners captured during conflicts around the globe, as well as prisoners from its own forces. Hampshire has been home to Europe's largest brick-built building, the Royal Hospital Haslar, and Britain's largest hospital, the Royal Victoria Hospital. In addition three of the most unique and diverse military cemeteries in the country can be found at Haslar, Aldershot and Netley.

Hampshire is also the birthplace of Britain's Navy, aviation and home to the British Army, boasting a close association with many military heroes and leaders. Among their number include King Alfred the Great, the Duke of Wellington, Lord Nelson, Major-General Gordon CB, Field Marshal Montgomery, Florence Nightingale, aviation pioneer Samuel Cody, aeronautical engineers Mr Reginald J. Mitchell and Miss Beatrice Shilling, and Air Commodore Sir Frank Whittle.

The extensive and diverse nature of Hampshire's military history is unparalleled anywhere in the country and it has an equally unparalleled military heritage. Such is the scale of that heritage it is not possible to comment on any aspect in depth in this publication. Rather, this book provides a concise and informative overview of the important periods in the county's history that have contributed to its remarkable military legacy.

In so doing, the book signposts readers to key heritage attractions and locations within the county celebrating Hampshire's rich and proud military heritage. It is the author's hope that readers will be inspired and stimulated to learn more about the county's military history and visit the many wonderful military heritage attractions and sites it offers.

1. Invasion and Occupation

The earliest identified inhabitants of Hampshire were the Iberic people who date back to 800 BC. Their nomadic lifestyle saw them follow the seasons across the county from north to south and back again in search of food and land to graze their livestock upon. The first major invasion of Hampshire's shores was by the Celts around 480 BC, who having crossed the Channel at its narrowest part, sailed westward along the Kent and Sussex coasts, arriving at Hampshire. With the Celts came new knowledge, weapons, tools and bronze. The second major invasion of Hampshire came around 50 BC by the Celtic-speaking Belgae, descendants of the Gaul's and Iberians from the iron-producing regions of Belgium and north-west Gaul. The Belgae brought with them iron metallurgy, replacing bronze implements of warfare and peace with iron ones.

Hampshire's third major invasion followed in AD 43. Under Emperor Claudius' direction, General Aulus Plautius arrived at Southampton from Gaul to subjugate southern Britain. General Titus Vespasian, having marched the second legion from London via Silchester, linked up with Plautius at Southampton. Following the same lines of advance that marked the conquests of the Celts and Belgae before them, they marched northwards up the Itchen Valley through the chalk hills, which they named Venta Belgarum, now the site of Winchester. During this campaign Vespasian beat two of the most powerful tribes in Britain, the Belgae and their allies the Durotriges, capturing over twenty hill forts.

The Romans had faced a well-organised army of infantry, cavalry and chariots fitted with scythes. The tribesmen painted their bodies with magical symbols in blue woad, wore helmets carved with figures denoting clans and armour made of plaited leather or plates of bronze. They fought with large shields, daggers, long iron swords, short spears, bows, darts and slings. After three months of fighting, the Romans withdrew to stop a rebellion in Gaul. Almost a hundred years passed before they returned to conquer the south, but by AD 50 Hampshire had become a Roman Province.

Over the next 350 years the Romans developed existing military sites, introduced new ones and fortified the coastline, cities, towns and hill forts. Today most of these defences have disappeared. Following their departure in AD 410, a short peace existed, which was broken in AD 437 by a period of warfare between Hampshire's two opposing factions: the Brittonic alliance led by Romanised Aurelianus Ambrosius and the pro-Celtic party led by Vortigern. The two forces met at the Battle of Guoloph at Wallop, Hampshire, and while the Britons were victorious, a further period of civil strife swept across southern Britain. Pict raiding parties plundered and terrorised the land, causing the Britons to seek Saxon help in exchange for land. Initially there were no conflicts between the Saxons and the Britons, but following a dispute over a failure to supply provisions, the Saxons entered into a lengthy war against them.

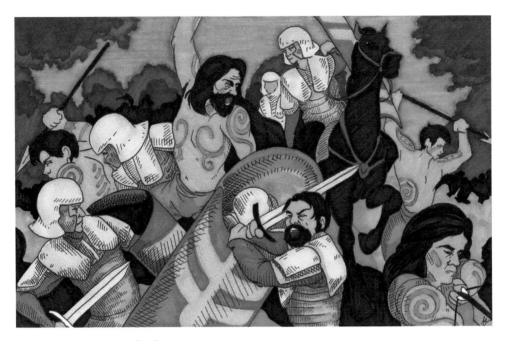

Roman invasion, AD 43. (LM)

Saxon attacks on the people of Hampshire began in AD 495. Raiding parties led by the Chieftain Cerdic and his son Cynric landed at the mouth of the Itchen, Southampton. In AD 508, having been reinforced by Jutes from Kent and South Saxon's from Sussex, Cerdic made a more determined attack, landing his forces at the mouth of the Hamble Southampton Water. Although King Natanleod had assembled the greatest army of Britons yet to fight the Saxons, he could not stop the invaders, and Cerdic, using Romano-British roads, moved from Lepe, near Calshot, to the north-west of Eling, pursuing Natanleod through the New Forest before crossing the River Test at Nursling.

As Natanleod's army retreated westward, the Saxons pressed them towards the ford at the River Avon, known since as Cerdic's ford, or Char-ford, where a major battle took place in which Natanleod and 5,000 of his men were slaughtered. After gathering reinforcements another great battle took place at Cerdic's ford in AD 519. His victory allowed him to form the kingdom of Wessex and become king. Today the site of these battles is known as the Bloody Marshes. The remains of the Romano-British road from Lepe can still be seen across the remote Beaulieu Heath, where it partially exists as a raised causeway.

In time the Roman town of Venta Belgarum, modern-day Winchester, became the capital city of the kingdom of Wessex. During the early years the West Saxons laid the political foundations for a state, which, after many struggles, saw the county graduate into the dominant state of Saxon rule, which eventually became the kingdom of England. With Wessex prospering, King Aethelred I faced many challenges and threats to his leadership. In AD 871 his rule was challenged by an invading force of Danes and their allies led by Halfdan Ragnarsson.

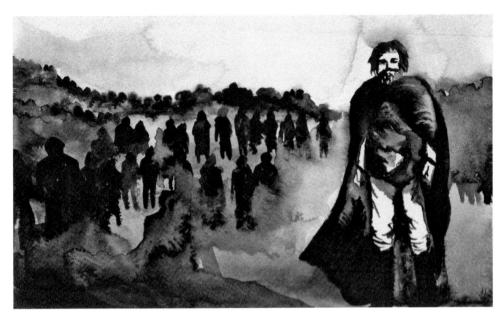

Cerdic, first king of Saxon Wessex. (LM)

Following a series of indecisive battles, the two sides met at Basing. Both sides suffered heavy losses and although the Saxons were defeated, the Danish victory was inconclusive. Following Aethelred's death Alfred succeeded him as king, and for seven years the Danes tried unsuccessfully to defeat his army before agreeing terms of peace.

The military impact of Alfred and his immediate successors on the county was significant. He created a network of wooden forts, which became fortified towns, cities and castles forming the basis for many of today's towns. At Itchen Alfred built a naval yard and began a shipbuilding programme, where he designed and tested new ships to oppose those of the Danes. Thus, on Hampshire's coast, Alfred built England's first navy. In AD 897 its effectiveness was tested when a fleet of marauding Danes arrived in the Solent. Both sides sustained considerable losses, but the Danes were defeated and those captured were hanged at Winchester. Over a 1,000 years after Alfred designed and tested his ships the construction and design of modern warships is still conducted on the coast of Hampshire.

During the next 167 years, eleven Saxon and four Danish kings took the throne, and united the kingdom of England, with Winchester as its commercial, political and military capital. In the years leading up to the Norman Conquest, Wessex, with its vast royal estates, cathedrals, monasteries and castles, became the most important part of the kingdom.

William, Duke of Normandy, led a Norman-French invasion force at Hastings, Sussex, in October 1066. Following his victory, William was crowned king of England and located his palace, military headquarters, and seat of government at Winchester. With most of Hampshire's nobles and potential rebel leaders killed at Hastings, the county suffered little military action following the invasion. Winchester was Normanised more than any other city in England, while Southampton became the continent's main gateway to England.

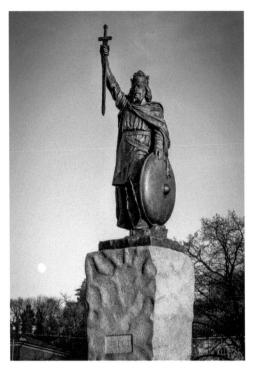

Left: Statue of King Alfred the Great at Winchester.

Below: King Alfred the Great's navy. (LM)

The establishment of a royal hunting ground in the New Forest and the building of stone castles, churches and cathedrals in the Norman style changed Hampshire's landscape forever. The Hospital of St Cross Church, Romsey Abbey, Winchester's Great Hall and Cathedral survive intact today. Some castles such as, Southampton, Odiham, Wolvesey and Winchester survive as isolated buildings or as ruins.

Although the Norman Conquest would be the last time England was successfully invaded, it would not be the last time an invasion was attempted, nor action needed to defend the sovereignty of the kingdom. By the early thirteenth century, however, Normandy was back in French hands and Southampton's status as the main port of passage to the continent had declined.

Between the thirteenth and fifteenth centuries, Hampshire's coastline was threatened many times by enemy fleets intent on attacking, plundering and sacking its ports and coastal towns. However, it was not only foreign enemies who attacked Hampshire. In 1265 English barons of the Confederation of English Channel ports in south-eastern England became jealous at the growing trade and status of Portsmouth and Southampton and attacked Portsmouth. Having killed many townspeople, they seized ships and cargo before burning the town.

At the start of the Hundred Years War the French and their Sicilian allies raided south coast towns. In March 1338, having no defensive sea wall to protect it, most of Portsmouth town was burnt down, and many of the population were raped and slaughtered by raiders from the French fleet flying English flags.

Left: The Great Hall at Winchester.

Right: Castle Watergate, Southampton.

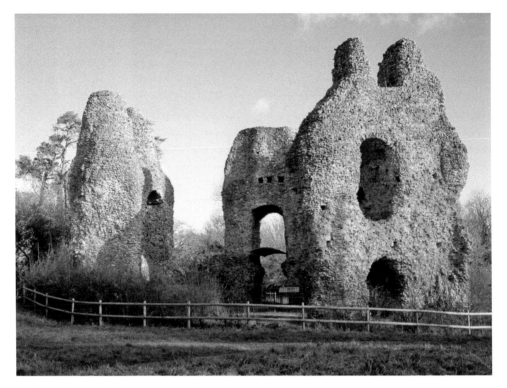

Odiham Castle.

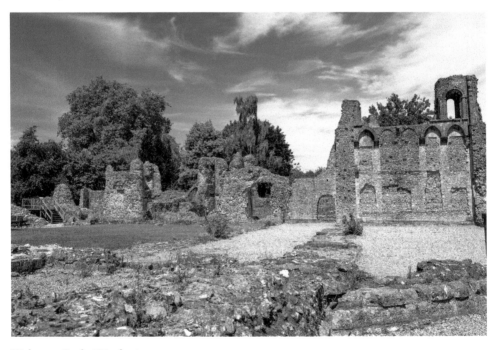

Wolvesey Castle, Winchester.

In October 1338, sixty French ships landed soldiers at the end of Bugle Street, Southampton. Raiders entered St Michael's Church, massacred the congregation, then rampaged through the town looting, murdering and setting fires as they went, burning many buildings including the churches of Holyrood and All Saints. Those who fled returned the following morning with reinforcements. On finding much of the town reduced to ash, they attacked the invaders, killing 300 and driving the rest back to their boats.

The French made another unsuccessful attack on Southampton in March 1339 and during the years that followed many alarms were raised. In 1377 they again attacked Portsmouth, but were driven back to their ships suffering heavy losses. Undeterred, the raiders plundered the Isle of Wight, destroyed Poole, and, buoyant with victory, attacked Southampton. They were eventually defeated at Southampton Water by 200 men at arms and 400 archers commanded by the Earl of Salisbury.

St Michael's Church,
Southampton.

Ruins of Holyrood Church, Southampton.

Portsmouth was attacked and burned by the French for the last time in 1380. Other places were not so lucky. The French fleet appeared off the Hampshire coast in early July 1416. Having blockaded the Spithead, they attacked the Isle of Wight and plundered the Isle of Portland. They were eventually countered later in the month by the English fleet, led by the Duke of Bedford. Eight vessels were captured, one was driven ashore and another was sunk with 800 crew. In June that year they returned to attack Southampton but this time they were beaten off by the guns of Lord Audley, who was in town en route to Normandy.

The Battle of Bonchurch occurred in the Solent during July 1545 between the French fleet of Francis I and Henry VIII's British Navy, anchored at Portsmouth. One hundred and fifty large ships, fifty smaller vessels and twenty French galleys failed to lure the larger British ships out of the harbour into open water. A fierce battle raged in which the French were beaten, although not before Henry saw the sinking of his flagship the *Mary Rose*. Turning their attention to the Isle of Wight, 2,000 French troops landed at three different locations to loot, burn and destroy villages before being forced back onto their ships.

In August 1558 under the command of Lord Howard of Effingham the British Navy fought the Spanish Armada off the coast of Hampshire. Although their light cannons pounded the Spanish ships, little damage was caused. In the following century, French and Spanish hostilities were replaced by maritime rivalry with the Dutch during the first Anglo-Dutch war. In February 1653, following a two day battle off the Isle of Wight Needles, the Dutch were eventually defeated by General of the Sea Robert Blake, who captured fifty merchant vessels and took 1,500 prisoners.

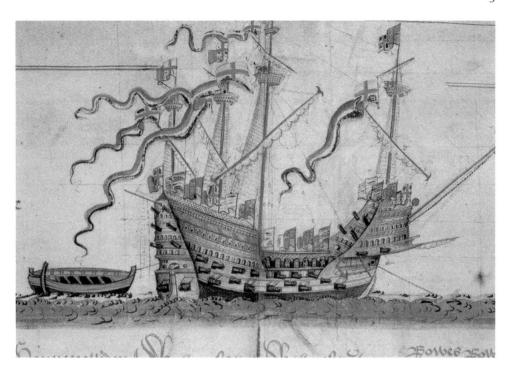

Above: Henry VIII's flagship the *Mary Rose*, 1545.

Right: Charles Howard, 1536–1624.

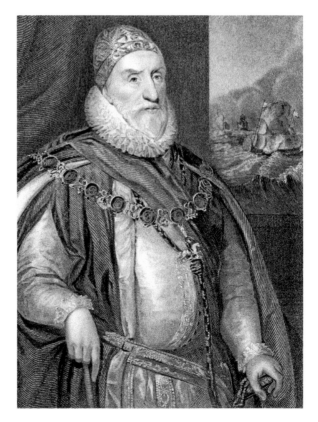

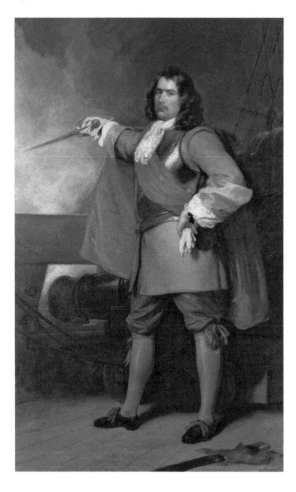

Robert Blake, 1598–1657.

During the second Anglo-Dutch war, the Dutch, commanded by Admiral Michiel De Ruyter, returned in June 1667 and prepared to attack Southampton. The mayor led the populace in building temporary fortification along the quay, while sailors manoeuvred guns into position. Seeing the strength of the resistance the Dutch stood down and set sail for the Channel. Although the threat of invasion from Spain diminished, the French threat would continue into the nineteenth century. While Britain would not be invaded again, it would engage in many wars, and Hampshire's support for its war effort and armed forces would be of great importance.

2. Defence and Detection

The first defences used by the Iberic people were basic single-bank and shallow-ditch earthworks following the contours of a hill to enclose an area, with a summit topped by a simple palisade. Over time more complex defences using two or three lines of earthworks were constructed to provide greater protection against invaders and local warring tribes.

The Celts use of bronze and their knowledge of new building techniques enhanced and improved these fortifications, creating forts of refuge to the surrounding clans against successive waves of invaders. These included the Belgae who, during their occupation, used Iron Age technology to strengthen the fortifications further, building a chain of hill forts along their borders with Sussex and Dorset. Across the county Bronze Age earthworks exist along with the remains of over forty Iron Age hill forts.

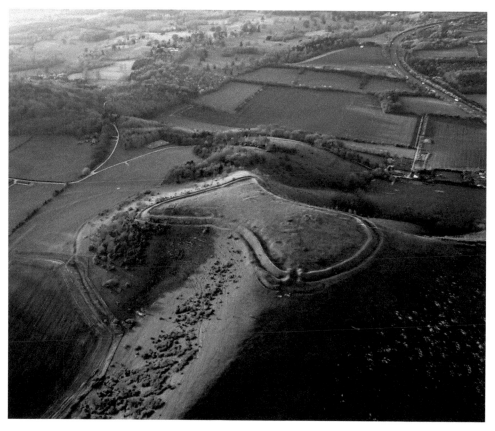

Beacon hill fort. (HA)

The largest of these hill forts was Walbury Camp constructed on Britain's highest chalk hill. Thirty-Three enclosed hectares straddles the border into Berkshire. Current estimates suggest 5,600 people were needed to defend it.

North-west of Winchester, Danebury Ring is an Iron Age hill fort built around 500 BC. Encompassing a fortified enclosure, it consists of two lines of concentric earthworks enclosing 5.5 hectares. It was excavated in 1859 by British Museum curator and collector Augustus Wollaston Franks. In 1989, following a twenty-year excavation of the fort's interior by Professor Barry Cunliffe, it became the site of the longest excavation of any hill fort in Western Europe.

Constructed in three phases, the fort included two gateways defended by timber gatehouses and earth banks reinforced with timber. A 6-metre-deep and 12-metre-wide ditch surrounded it, broken by two ramparts topped by a low stone wall rising 16 metres from the bottom of the ditch to the top of the wall. The eastern gateway was defended by earthen walls on either side of a curved path to the gate.

Extra defensive banks on both sides forced attackers to slow down and follow a less direct route so that defenders could throw stones and other missiles. The south-west gateway defences had a narrow path leading to the gateway, causing attackers to gather in a small enclosure where the defenders could attack them with little reply. Evidence of burning at these gates suggest the fort experienced several major attacks.

However adequate the Iron Age defences were for tribal warfare, they were no match for a direct assault by 5,000 organised, well-equipped, battle-hardened Roman legionaries. Just as gunpowder would make castle walls vulnerable, so Roman catapults succeeded in subjugating hill forts. The Romans, having conqured Hampshire, created a province based on two towns, Calleva (Silchester) and Venta Belgarum (Winchester), with fortified stations at Clausentum (Bitterne) and Portus Magnus (Portchester). Calleva and Venta Belgarum were connected to other important centres across occupied Britain by fast new roads.

One of the most impressive and well-preserved Roman monuments in Britain is the castle of Portchester on the northern shore of Portsmouth Harbour. Built as a square, its 182-metre-long walls are surrounded by a single ditch on three sides and a double ditch on the landside. Its walls are 6 metres high and 3 metres thick, enclosing an area of 9 acres. Much of the outer defences have been lost, although it's still possible to walk along walls once paced by legionaries, and fourteen of the twenty bastions of the fort remain. Built towards the end of the third century AD, it was one of eleven forts built at strategic locations along the south-eastern coastline. Each fort had a large garrison and adjoined harbour from which fast warships could set sail to intercept enemy and pirate ships.

The Romans expanded and reinforced earthwork defences throughout the county. They fortified the tribal towns of Calleva and Venta Belgarum and in time stone walls were cut into the earthworks adding bastions and gates. Although the walls at Winchester remain hidden beneath later mediaeval ones, a small section can be seen at the bridge over the Itchen. At Silchester wall projections remain along the inner face of the town wall where fighting platforms once existed, and at the South Gate there are the bases of guard chambers. Southampton formed part of the Roman/Saxon shore command. The Romans founded and fortified the seaport of Clausentum, modern Bittern, with large

Roman army attacking a hill fort. (LM)

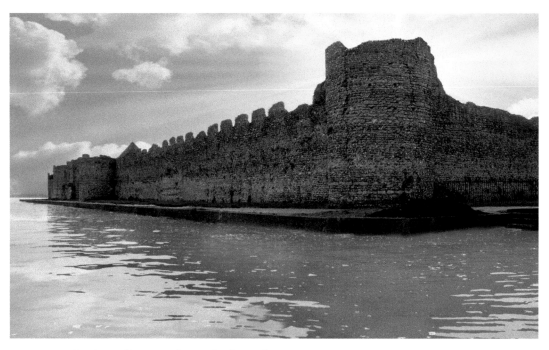

Roman bastion walls at Portchester Castle, Fareham.

Left: Section of Roman defensive wall at Winchester.

Below: South gatehouse, Silchester.

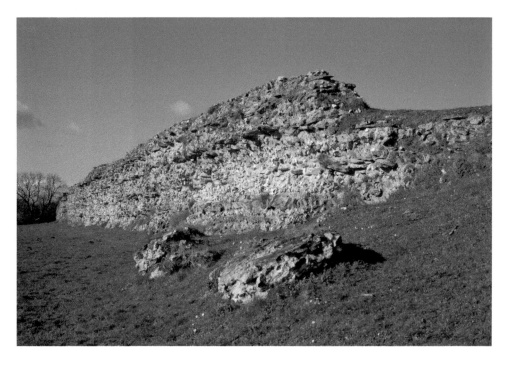

stone walls and towers to protect the transference of goods from sea-going vessels to river barges bound for Winchester. Today Clausentum and the later Saxon and medieval defences are buried under the urban sprawl of Bitterne Manor, which is now a suburb of Southampton. However, small sections of ditch can be seen in Bitterne Manor Park and some Roman and medieval masonry form part of Bitterne Manor House.

The Saxons developed an integrated system of defence for the kingdom of Wessex, which included a series of fortified settlements known as burghs (defensive strongholds and muster points) connected by Roman roads and hilltop beacons. When the hilltop beacon signalled danger, the roads enabled them to move at speed either towards the safety of the burghs or from the burgh to engage the enemy.

Most burghs were built during the reign of King Alfred the Great. Some were constructed from scratch, creating large earth banks topped with wooden palisades, gates, towers, ditches and revetments of fire-hardened stakes. Others were erected on former hill fort sites or, like at Winchester, Southampton and Portchester, built upon Roman fortifications. In the eleventh century the Saxons modified Portchester Castle, and rebuilt the land gate.

The Normans were master castle builders who, following their invasion in 1066, began a building programme to increase their control over the English people. The first castles were artificial hills. Known as a motte, they had a wooden tower on top and an enclosed defended area known as a bailey at its base. Defended by a ditch, the bailey had a bank on the inside and a palisade on top. The remains of several motte-and-bailey castles can be seen across the county.

Hampshire's best-preserved motte is the Alverstoke Motte on the east bank of the River Alver near Gosport. The motte is 4.5 metres above the bailey and surrounded by a well-preserved bank. West of Winchester is Ashley Castle, a 50-metre-wide pentagonal ring work bailey with foundations of a rectangular building and a 12-metre round tower. The castle's 2-metre-deep moat, although overgrown with trees, can be clearly seen.

Having established their rule, the Normans began replacing mottes with castles such as Odiham Castle, North Warnborough. Following its besiegement in 1216 Odiham motte and bailey was rebuilt with a rare and unusual octagonal great tower. Most Hampshire castles saw no military action, with only twelve of the thirty being attacked, although the threat of invasion and rebellion remained ever present.

Up until Tudor times defences changed in line with developments in warfare or in response to military experiences. As attacks grew in size and number, key towns were refortified. At Portsmouth in 1416 a stone round tower was built to defend the harbour entrance. Constructed upon existing earth and timber defences, the tower was connected by a large chain boom to a wooden tower on the Gosport side. In 1429 a stone square tower was added to defend the seaward side of the boom. Both Portsmouth and Southampton became garrisons and their fortifications were continually strengthened.

Winchester's gatehouses were strengthened with gun ports and several homesteads and monastic buildings across the county were fortified by adding moats, earthworks and towers. The changing political climate meant there was less need for new castles and the introduction of gunpowder in warfare had made traditional stone wall fortifications vulnerable resulting in them becoming obsolete.

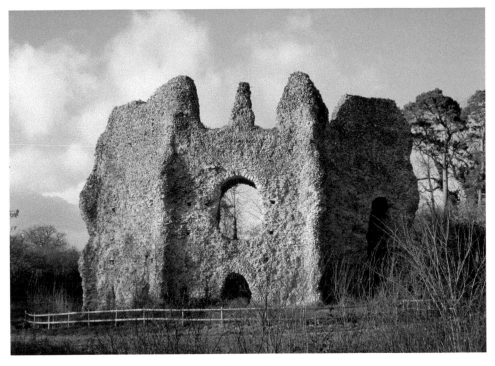

Odiham Castle, site of a former motte-and-bailey castle.

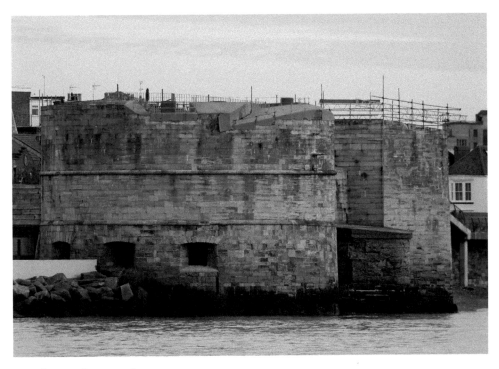

Round Tower, Portsmouth.

Square Tower,
Portsmouth. (JL)

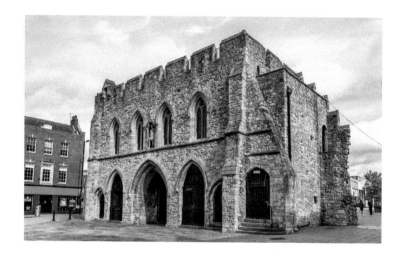

Southampton
Gatehouse.

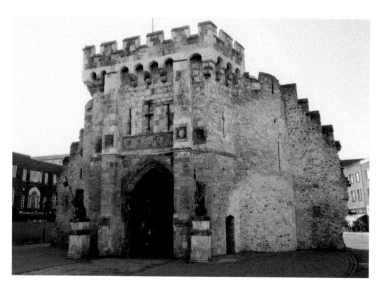

Gatehouse,
Winchester.

As the threat from abroad re-emerged, between 1539 and 1547 Henry the VIII co-ordinated a national defence programme and this delivered the next evolution in coastal defences. Expecting a French invasion, Henry constructed a chain of thirty new well-armed gun batteries close to the shore along the south coast. Known as Device Forts, they had a low round profile, thick walls and a central keep. Their round style deflected cannon balls while giving all-round firepower against enemy warships.

Eight similar forts of varying designs safeguarded the coast of Hampshire. Defending the eastern approach to Portsmouth, Southsea Castle has a square central keep, two rectangular gun platforms and angled bastions to the front and rear.

At Southampton, Calshot Castle fitted with large muzzle-loading guns, protected the harbour while Hurst Castle, with its central keep, three bastions and twenty-six guns, was one of the most powerful forts on the coast and defended the western entrance to the Solent. The castles of West and East Cowes provided flanking protection against anchorage at the entrance to the River Medina. Southampton Water near the Solent was protected by Netley Castle, which included a central stone keep and two flanking gun platforms.

In 1544 at Hilsea, Portsmouth, the first earthwork defences were built, including a moat that could be flooded, just north of Ports Creek, to protect the naval interests from an inland attack. Later additions to the defences included St Andrew's Castle. Constructed on the site of an Iron Age hill fort, this defended the entrance to the River Hamble and included a keep and a gun platform protected by a moat. Decommissioned in 1642, its remains have been destroyed by coastal erosion. Fort Cumberland, a bastion defence to

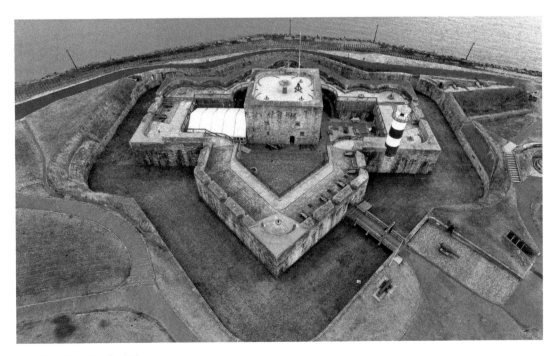

Southsea Castle. (JL)

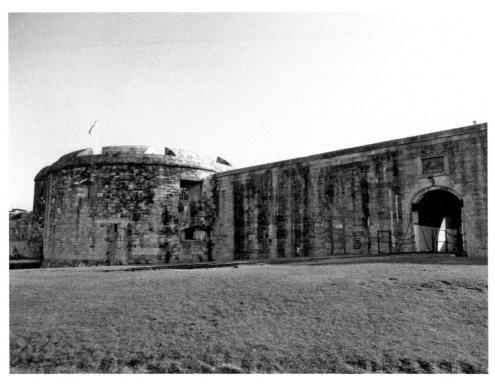

Calshot Castle, Southampton. (DT)

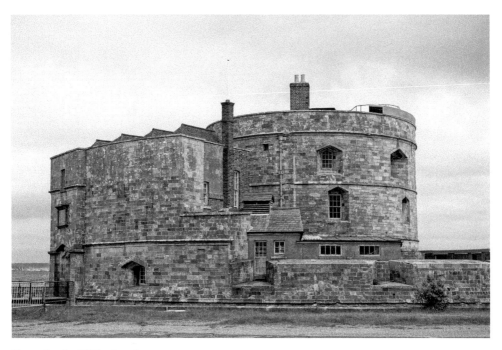

Hurst Castle, Milford on Sea.

the east of Portsmouth, protected the entrance to Langstone Harbour. This was to prevent invading forces landing and moving overland to attack the Royal Naval Dockyards at Portsmouth. Built in 1740 it has a pentagon shape, low profile and gun emplacements.

During the 1850s naval warfare was revolutionised by the introduction of steam, and the development of new armaments brought huge improvements in the power and accuracy of artillery. This, together with the increasing strength of the French Navy, created a new fear of invasion that captivated the French Prince De Joinville, who, following his visit, published a pamphlet describing how Britain could be successfully invaded and how Portsmouth, Plymouth and even London could be destroyed or seriously damaged.

The prince viewed the defences of Portsmouth with contemptuous amusement, revealing that not a single gun was mounted at the Round Tower, Point Battery, Spur Battery, or Fort Hailsworth, while Fort Monckton only had a few obsolete 18- and 24-pound cannons. He noted the twenty-one guns mounted on the Kings Bastion battery were only used for ceremonial salutes, and that one recent salute had killed ten artillerymen when a gun exploded. As for the guns of Fort Cumberland, he believed they were incapable of reaching ships far out at sea. Resultant public anxiety prompted action and new guns were hurriedly mounted, batteries erected and old earthworks replaced.

In 1757 defensive lines were created south of Hilsea to defend against seaward attacks. These lasted until 1858 when enhancements were made that included bombproof casements, cannons and turret guns. However, a review in 1859, commissioned by Prime

Bastion wall east side of Fort Cumberland, Portsmouth. (MC)

Minister Lord Henry Palmerston, showed that none of the existing fortifications protected the dockyard and harbour from attack from Portsdown Hill. Despite considerable opposition the Fortification Bill was passed, and substantial new defensive works were undertaken during the 1860s. Improvements to the fabric of the stone Square Tower, Kings Bastion, Point Battery, Southsea Castle, Lump's Fort and Fort Cumberland were made and four new Solent forts – Spitbank, St Helen's, Horse Sand and No-man's-land – were built. In addition, at Hurst Point, Milford on Sea, Hurst Castle was rebuilt, and the Isle of Wight and Needles passage was fortified by the construction of Fort Victoria.

The Hilsea Lines moat was widened and earthworks strengthened. Across the harbour on the western side of Gosport six forts were constructed along the seafront: Gomer, Grange, Rowner, Brockhurst, Elson and Fareham. Built to protect Portsmouth Harbour from an inland attack, the forts had circular keeps, low-profiles and were protected by moat banks. On the top of Portsdown Hill five forts – Purbrook, Widley, Southwick, Nelson and Wallington – were built, along with two supporting batteries to protect the harbour from any land attack from the north or east. The Portsdown forts, known as Palmerston's Follies owing to their questionable militarily value, was the most costly and extensive system of fixed defences undertaken in peacetime and were the last self-contained forts to be built in Britain.

Southampton and Portsmouth have long served as gateways to war, with troops embarking to fight in campaigns around the world, most notably during the Napoleonic War, the Crimean War, Boer Wars, and with the British Expeditionary Forces of the First and Second World Wars. As fears of invasion subsided, coastal defences remained largely unchanged. In 1914, Hampshire's coast was no longer viewed as a prime target for invasion. However, the need to protect its military and merchant assets remained. As the land war raged on in Europe, defences to combat new threats such as aerial and long-range coastal bombardments, hit-and-run operations by torpedo boats and submarine attacks were enhanced.

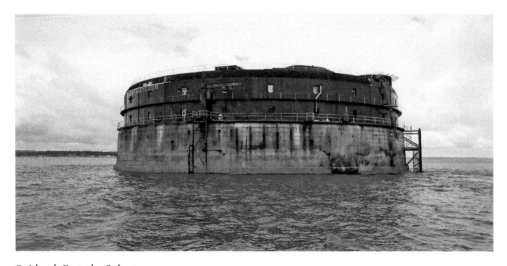

Spitbank Fort, the Solent.

Fort Nelson, one of Palmerston's Follies.

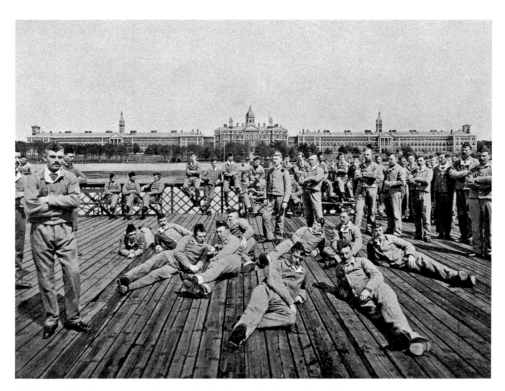

Soldiers at Southampton awaiting embarkation to the Boer War. (WI)

During the First World War Southampton Docks became the primary Military Embarkation Port for France. Troops marched through the Bargate on their way to the trenches, many never to return. A boom of linked hulks was placed across the mouth of Southampton Water and new batteries, search lights and anti-submarine nets were installed. Several experimental anti-aircraft guns were placed across Portsmouth and Southampton, while along the south coast a network of listening posts was established.

Experiences in France along with developments in technology brought changes in tactics, and soon trench warfare replaced cavalry charges and fighting in open ground. In Britain replica battlefields were created to train soldiers in trench warfare and of the twenty recorded sites across Britain, the best preserved is found beneath heathland on Ministry of Defence land in Gosport. Discovered in 2014 by Gosport Council's conservation officer Rob Harper, it covers an area the size of seventeen football pitches with two sets of opposing trench systems and a no-man's-land between them.

When France fell in 1940 the south coast once more feared invasion. Portsmouth and Southampton with their naval and commercial ports were considered prime targets for attack, along with airfields, munitions dumps and factories. While Aldershot, Southampton and Portsmouth had their own defence plans and fortifications, General Ironside Commander-in-Chief of Home Forces, fortified the other most vulnerable locations.

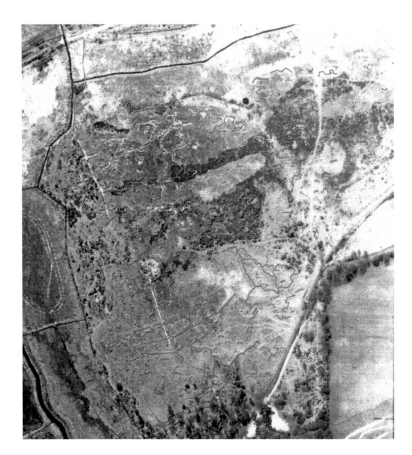

Highlighted 1943
trench system,
Gosport. (HE)

Selsey Bill, Portsmouth and Poole Harbour were promoted as window displays of defensive strength that Ironside termed a 'Coastal Crust'. Behind them he created a network of anti-tank obstacles, and reinforced natural features with hundreds of bullet- and bomb-proof pillboxes, gun emplacements and demolitions (rail, water and land bridges rigged with explosives). With aerial bombardment more prevalent than in the First World War, at Southampton and Portsmouth anti-aircraft guns were immediately installed. Over time other parts of the county received them, notably Borden, Farnborough and key airfields.

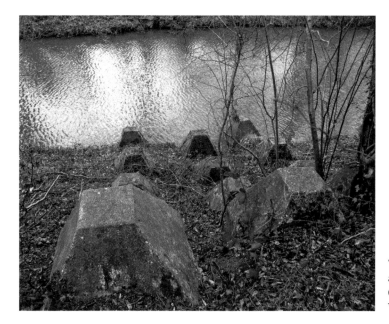

'Dragons Teeth' anti-tank defence, Crookham Wharf. (TD)

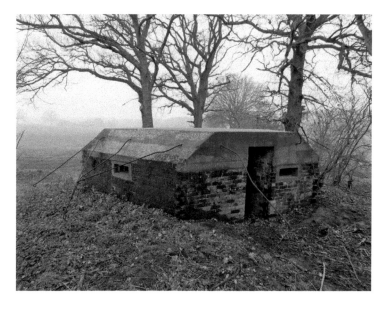

Shellproof type 22 pillbox, GHQ Line A, Hampshire. (TD)

Barrage balloons were also deployed at Southampton, Gosport and Portsmouth to prevent low-level strafing and bombing, while citizens were provided with personal and communal air-raid shelters. During the war Portsmouth and Southampton experienced heavy and repeated bombing due to their strategic importance. Between 1939 and 1944 bombing claimed the lives of 930 people in Portsmouth and 630 in Southampton. Both cities were subsequently struck by V1 rockets and fifty such rockets exploded across the whole county.

Between the 15 and 25 June 1940 hundreds of merchant and private vessels sailed from Portsmouth and Southampton to take part in the mass evacuation of troops from Dunkirk. In 1944 Hampshire was the epicentre of preparations for Operation Overlord, the Allied invasion of Normandy. During the build-up, Southampton became a huge armed camp, with rows of tanks and other vehicles parked along miles of roadsides and in fields. During Operation Overlord, the Royal Pier, one of three main marshalling points, saw over 3.5 million Allied soldiers including 2 million American troops embark on the largest amphibious invasion in history.

Much of the planning for Operation Overlord took place at the Allied Naval Headquarters in Southwick House, Fareham. By 1941 the house had requisitioned and commissioned as HMS *Dryad*, becoming home to the Allied Naval Headquarters. A large wall mounted D-Day map, built by toymakers Chad Valley, which was used to plot the progress of the invasion, remains preserved in what was the Naval war room. It was from Southwick House that General Eisenhower gave the momentous order 'Ok, let's go' to start the invasion.

Southwick House. (HB)

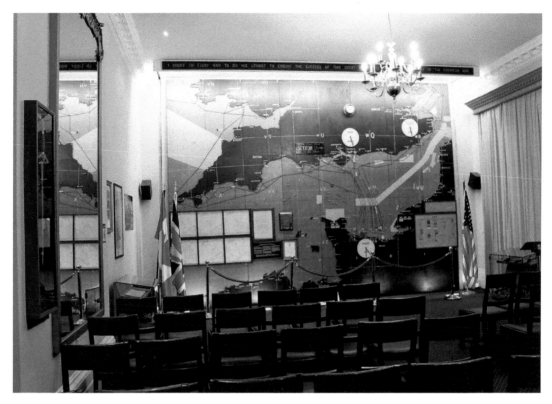

Map room, Southwick House.

At Marchwood near Southampton a temporary port was built in 1943 to aid the D-Day landings and construction of Mulberry Harbour pontoons. After the war the port remained in use and in April 1982 Marchwood played a major role in supplying vessels of the Royal Fleet Auxiliary, despatching ships, vehicles and equipment needed during the Falklands conflict.

HMS *Invincible* and *Hermes* were the first ships to set sail from Portsmouth for the Falklands. The fleet was attacked many times and some ships did not return. The Portsmouth ship HMS *Sheffield* was hit by an Exocet missile; twenty of her crew were killed and she later sank on 10 of May 1982, being towed home. This was the first Royal Navy vessel sunk in action since the Second World War. In July 1982 Flagship HMS *Hermes* returned to her home port Portsmouth, to ecstatic scenes not seen since troops returned from the Boer Wars in the early twentieth century.

Lessons learned during the conflict resulted in Marchwood Military Port being expanded, with additional jetties added to facilitate roll-on roll-off vessels. In 1991 and 2003 ships were again made ready at Portsmouth and Southampton, setting sail for the first and second Gulf Wars. More recently Marchwood has supported overseas operations in Afghanistan, as well as operating bases and training areas in Kenya, Canada, the Falkland Islands, Germany, Northern Ireland and Belize and exercises in the UK, Norway, Germany, the Middle East and the USA.

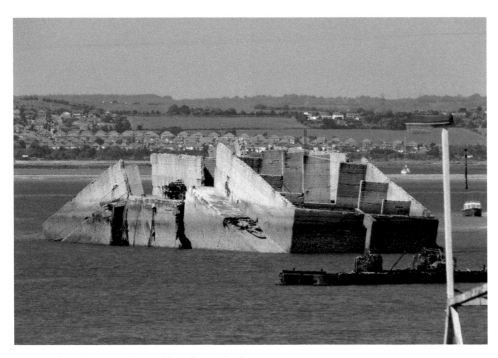

Section of Mulberry Harbour off Hayling Island.

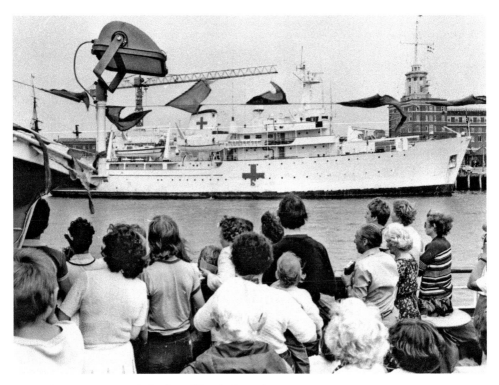

Troops leaving Portsmouth for the Falklands. (AMM)

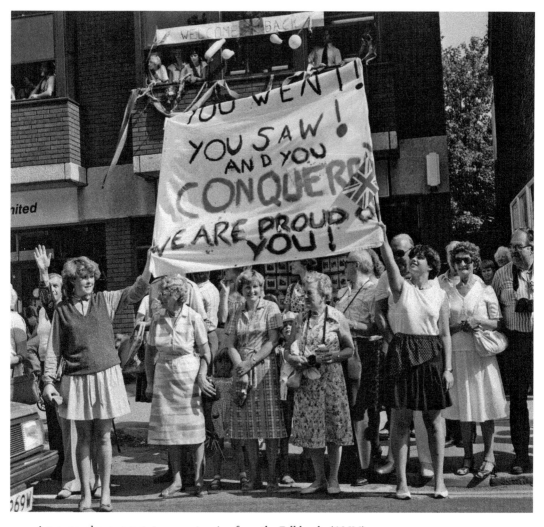

A warm welcome greets troops returning from the Falklands. (AMM)

Today the site is privately owned but continues to meet the defence requirements for operational and overseas deployment and training. This will ensure that the military outputs can still be met while allowing greater economic and commercial benefit to be realised from the site.

Between 1947 and 1990 a state of political and military tension existed between the democratic West and communist nations in Eastern Europe and Asia. This new Cold War heralded a series of conflicts and international crises that increased tension, raised suspicions and fuelled paranoia that nuclear war was imminent. Britain's pre-emptive response was to build hundreds of secret underground bunkers to perform a variety of functions including protecting key military, political and other important figures should an attack happen. After the Cold War was over, many bunker sites, like the Royal Observer Corp (ROC) bunker in Winchester and the Standby Local Authority bunker in Bitterne, Southampton, were demolished for housing developments.

Today few reminders of the Cold War remain in Hampshire, and most of these have restricted access. At Gosport the Borough Control Bunker can be seen, forming a single-storey blockhouse, while nearby Portsdown Hill, Portsmouth, is a two-level bunker with heavy blast doors housing a Protected Repeater Station intended to boost the strength of telephone signals following an attack. Also housed at Portsmouth, within Fort Widley, was Portsmouth District Council Emergency Centre and the Hampshire County Standby Bunker.

Located close to Southampton are the Eastern Sub-Control at Bitterne, and Southampton City Council's Control Centre at Bassett. Near Twyford, Winchester, there is a large bunker created from an old covered reservoir. Hampshire's best example of a Cold War bunker is the restored ROC, Observation and Monitoring Post at Lepe Country Park, which was part of a secret network of bunkers built to warn the public of a nuclear attack and monitor the after effects of any explosion.

Hampshire's connections to the Cold War were not merely defensive. In 1961, former Royal Navy sailor Harry Houghton was part of the Portland Spy Ring. Working as a clerk at HMS *Osprey*, Portland, he collected and passed on secret information at a toilet block in Alresford near Winchester. Eventually arrested and convicted of spying, he was sentenced to fifteen years imprisonment.

Gosport Borough Control Bunker.

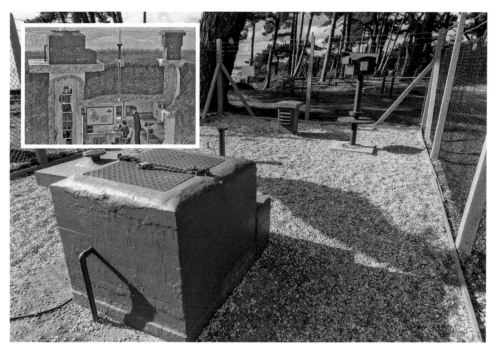

Royal Observer Corps Cold War Observation Post, Lepe Country Park. *Inset*: The observation post below ground.

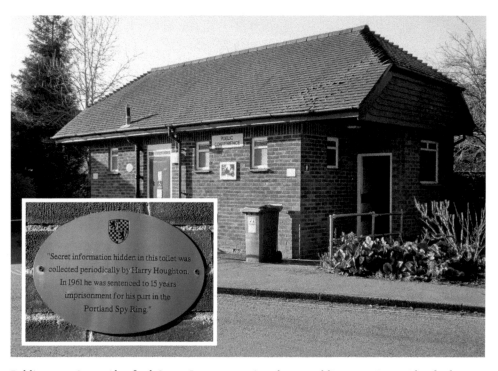

Public convenience, Alresford. *Inset*: Commemorative plaque, public convenience, Alresford.

Guy Burgess, another Cold War spy and member of the Cambridge Five Spy Ring, caused controversy following his death in Russia in 1963. His dying request was to be buried alongside his father in West Meon, Petersfield. Despite local opposition not wanting a traitor buried in their churchyard, they agreed to his interment on condition that no monument or inscription was added to his father's grave.

Melita Sirnis, aka Norwood, is Hampshire's Cold War daughter. Born in Bournemouth in 1912, she was schooled in Southampton and attended university college where she became embroiled in anti-fascist activities, joining the Labour Party before secretly joining the Communist Party of GB. Recruited to spy for the Soviet secret police, for forty years, she passed on a range of secrets about the British atomic weapons project, enabling the Soviets to test an atomic bomb four years earlier than predicted. Having retired from spying in 1973, she was exposed in 1999 aged eighty-seven but not prosecuted due to the time that had passed.

The Cold War submarine HMS *Alliance* can be seen on display at the Royal Navy Submarine Museum Gosport.

Grave of spy Guy Burgess.

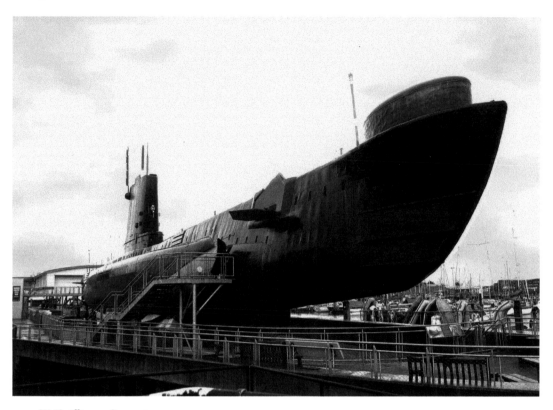

HMS *Alliance,* Gosport.

3. Civil War

Hampshire played a significant role in the struggle between Charles I and his parliament. The brief defence and capture of Portsmouth was a huge gain for the Parliamentarian cause and the gallant stands by the Royalist garrisons at Winchester Castle and Basing House greatly affected the outcome of the war.

The Battle of Alton, Hampshire, also known as the Storm of Alton, was one of the most savage encounters of the English Civil War and it was the first decisive defeat of Sir Ralph Hopton, leader of Royalist forces in the south. Garrisoned at Alton, on the 13 December 1643 the Earl of Crawford and his Royalist troops were caught by a surprise dawn attack from Parliamentary forces led by Sir William Waller. Crawford's men had watched the main roads but failed to prevent the Parliamentarians approaching undetected along minor roads. Crawford and his Royalist cavalry fled Alton for Winchester to seek reinforcements, leaving Colonel Boles and the infantry to mount a defence. Outnumbered and under artillery fire, Boles Royalists were routed from one defensive position to another. Eventually the Parliamentarian troops ran them to ground inside the Church of St Lawrence, throwing grenades at them through the church windows. Firing out of the church windows and from behind horse carcasses, the remnant of Boles men fought a short-lived last stand, only surrendering when Boles was killed. The Battle of Alton was the first battle in the English Civil War to use leather guns, and holes from the fighting can still be seen in the church door and the walls inside the church.

Three months later in March 1644 the Battle of Cheriton took place between Sir William Waller's Parliamentary forces and the Royalist forces commanded by the Earl of Forth, on open fields and woodland to the east of the village. The battle resulted in a major turning point in the war and an important victory for the Roundhead contingent that halted the Royalist advance to London and helped shape the future of England.

Despite the Royalist success, their advantage was not exploited, and this handed victory, and control of Hampshire to the Parliamentarians. While the battlefield is undeveloped, the landscape has changed since the seventeenth century; now small enclosed fields, bordered by tall hedges occupy the once open slopes and ridges then occupied by the two forces. Cheriton Wood still survives intact, and the narrow lanes that restricted access through the enclosed fields are accessible today.

A battlefield monument stands near the Royalist command post where the Earl of Forth and Sir Ralph Hopton directed the battle. The Battle of Cheriton Project Ltd have created an informative 5-mile-long self-guided tour, lasting three to three and a half hours that enables visitors to walk in the footsteps of those involved in the battle.

Nearby Basing village gave shelter to many regiments of Parliamentary soldiers as the famous three-year siege of Basing House unfolded. There was much destruction, and their zealous Puritan beliefs were vented on St Mary's Church and its monuments. The coat of

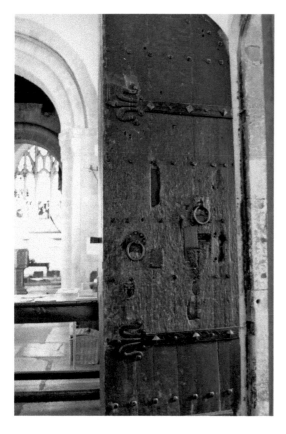

St Lawrence's Church door showing musket ball damage.

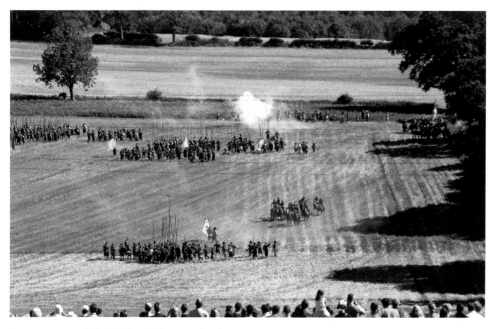

Re-enactment of the Battle of Cheriton. (MP)

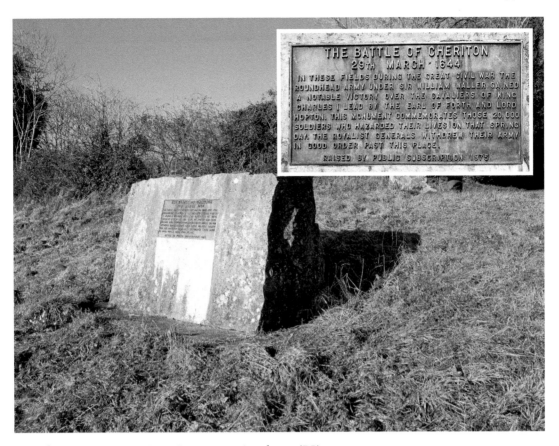

Cheriton Monument. *Inset*: Commemorative plaque. (DP)

arms of the local aristocratic family the Paulet's and statues were torn from their niches. The Paulet vault was broken into and the bones of the dead strewn across the floor, while the great lead coffins were melted down and used for bullets. On the outer western gable of the nave hidden by ivy, only the statue of the Virgin Mary survived unscathed. The Parliamentarians turned the church into stables, creating row upon row of horses stabled in the aisles. Their graffiti, bullet holes and other damage can be seen across the church's façade, most notably a large breech (later filled with bricks from Basing House) beneath the west window of the south aisle.

During the Civil War, Winchester was occupied by both the Parliamentarian and Royalist forces changing hands several times. In 1642 the Parliamentarians smashed the cathedral's huge mediaeval stained-glass west window. Chests holding the bones of early kings were toppled and their bones scattered and used to smash the stained-glass windows. Soon after Winchester fell back into Royalist hands. In 1660 the broken glass was gathered up and randomly put back together to make a giant mosaic that can be seen today. In September 1645 Cromwell returned and demanded Royalist surrender. When they refused, his forces breached the walls and stormed the cathedral once more desecrating it.

The first Parliamentary assault on Basing House in 1642 was carried out by Colonel Richard Norton. The assault was renewed by Sir William Waller in 1643 and again by Colonel Norton in 1644. The final attack conducted by Oliver Cromwell himself in October 1645 resulted in Basing House being taken by storm and destroyed. Royalist forces under the control of the 5th Marquess of Winchester numbered 200. Faced with Cromwell's ultimatum to surrender and knowing refusal meant no quarter would be given once the house was captured, they rejected the offer. Despite Cromwell's repeated bombardment of the house, Royalists resisted attempts to capture it. Cromwell finally assaulted Basing House with 7,000 Parliamentary troops, scaling the walls and breaching the defences within minutes.

Once inside, fighting turned to hand-to-hand struggles interspersed with looting. Other than those who escaped over the walls the entire garrison of Basing House including six Catholic priests were killed in fighting or put to the sword during the final attack. During the bombardment of Basing House red-hot shot was used. One hot shot became embedded in the frame of the house creating a fire that burnt for twenty hours and during which Royalist soldiers imprisoned in the basement were burnt alive.

The House of Commons resolved that the house, garrison and walls at Basing House be demolished, allowing anyone who wanted to take any stone, brick or other materials they wanted to do so. Today Civil War re-enactment groups perform in the grounds. The extensive ruins of the largest private house in Tudor England remain as a heritage site, along with the only building to have survived the battle intact, the Great or Bloody Barn as it became known, which still bears its battle scars.

Garrison Gate, Basing House.

Cellar, Basing House.

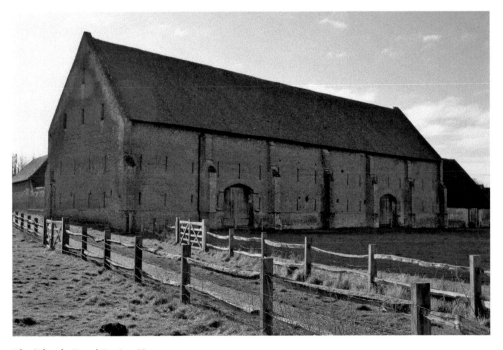

The 'Bloody Barn', Basing House.

4. The Tigers of Hampshire

At the heart of the Hampshire's military heritage are the generations of men from across the county who have served in the Hampshire Regiment and its forerunners, the North and South Hampshire Regiments. Formed in 1881, the Royal Hampshire Regiment served until 1992, although the regiment has a much longer and prouder tradition than these dates suggest. One of the fiercest fighting regiments in the British Army, it holds thirty-eight battle honours that include Blenheim, Ramillies, Oudenarde, Dettingen, Culloden, Minden, Afghanistan, The Somme, Passchendaele, Ypres, Dunkirk, Cassino, Normandy Landings, Caen and Rhine Crossing.

The origins of the regiment date from 1702, when Queen Anne asked Thomas Meredith to raise a regiment of infantry at the start of the War of the Spanish Succession. Within months his regiment, the 37th Foot (later the 1st Battalion, the Hampshire Regiment),

Thomas Meredith. (RHR)

was fighting the French in Europe. Since then the Hampshires have been a prominent fighting regiment of the country. The 37th Foot became two regiments in 1758, creating the 37th North Hampshire Regiment and the new 67th South Hampshire Regiment. In 1805 the 67th arrived in India, where it stayed until 1826. Recognising their twenty-one years' service in India, they were assigned the figure of the Royal Bengal Tiger to their colours and in time their cap badge, earning them the nickname 'The Tigers'.

For over 175 years, the tiger was synonymous with the Royal Hampshire Regiment. In 1881 reforms saw British infantry regiments standardised by counties, comprising two regular battalions and two militia battalions. The 37th and 67th formed the Hampshire Regiment, which in 1946 became the Royal Hampshire Regiment. Officially the numbers 37th and 67th ceased being used, but the 1st Battalion of the new regiment kept the tag 37th, and the 2nd Battalion kept the 67th. Following further reforms, the Royal Hampshire Regiment amalgamated with the Queen's Regiment to form the Princess of Wales's Royal Regiment (1PWRR) in 1992.

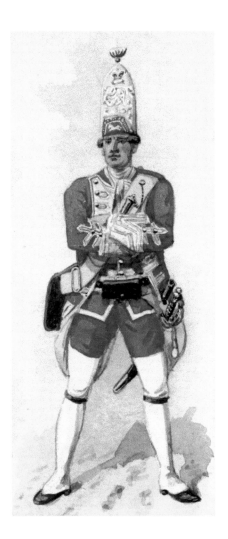

Uniform of the 37th Foot. (RHR)

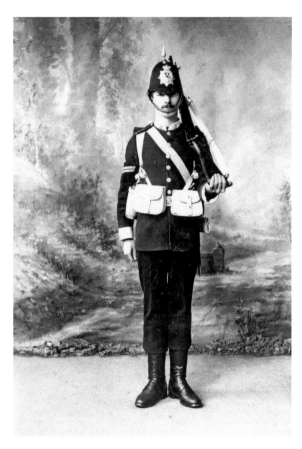

Soldier of the Hampshire Regiment, 1881. (RHR)

The battle honours gained by the Royal Hampshire Regiment, and its predecessors, the 37th and 67th Regiments, tell the history of the regiment through the battles and campaigns in which its men fought. The most decorated of British Army regiments, it has fifty-seven recipients of the Victoria Cross. Today the Tigers form part of the Princess of Wales's Royal Regiment newly formed in 1992.

The Royal Hampshire Museum can be found in Serle's House, Southgate Street, Winchester and was previously the headquarters of the Royal Hampshire Regiment and part of the former Peninsula Barracks. The museum charts the long and gallant history of the regiment, Militia, Rifle Volunteers and volunteers from 1702 onwards.

Winchester has six military museums inside the former Peninsula Barracks. Now a historic heritage hub, the barracks has its own unique history. During the Napoleonic Wars the barracks housed 3,000 permanent troops. Many regiments were temporarily billeted there between 1815 and 1856, including the 43rd Light Infantry and the 60th Rifles. In 1858 the barracks became the home base and training depot for the King's Royal Rifle Corps (KRRC) and the Rifle Brigade (RB).

Within four weeks of the outbreak of the First World War 5,000 reservists and 30,000 volunteers had passed through the gates of the training depot, destined to join the KRRC and RB. At the outbreak of the Second World War so many recruits volunteered to

Serle's House, The Royal Hampshire Regiment Museum.

join the KRRC that they had to be trained at Bushfield Camp, 2 miles outside Winchester. Between 1943 and 1944 Peninsula Barracks housed the 60th Infantry Regiment of the 9th (US) Infantry Division while preparing to take part in the D-Day landings in Normandy.

Following the war, training resumed at the Rifle Depot, and between 1951 and 1986 the Rifle Depot was retitled the Green Jackets Depot, the Green Jackets Brigade Depot, the Rifle Depot and the Light Division Depot (Winchester). Peninsula Barracks closed in December 1985, and in 1986 the depot and training function moved to the purpose-built Sir John Moore Barracks, Winchester.

In 1994 the Ministry of Defence (MOD) sold most of the site for private residential use, with the former parade ground landscaped and renamed Peninsula Square. Three buildings were kept as MOD offices, and to house Winchester's Military Museums. Within the barracks the Regimental Museum of the King's Royal Hussars, the Royal Green Jackets (Rifles) Museum, the Gurkha Museum and the Museum of the Adjutant-General's Corps can be found. Each museum tells its own story and has direct links to Hampshire's military heritage.

Winchester has a long and proud connection with many army regiments and corps, the heritage of which is preserved within its buildings, monuments and museums. However, despite such connections it was Aldershot, as will be explored, that would become the home of the British Army.

Ghurkha Museum, Peninsula Barracks.

5. Detention and Interment

Portchester Castle, used since Roman times and during all the major wars of the eighteenth century, is probably the oldest prisoner of war (POW) prison in Britain. Records show Portchester first became a POW depot during the Anglo-Dutch wars of the 1660s. Signatures and inscriptions by French prisoners held during the Seven Years' War (1756–63) can be seen carved into the stonework.

However, it was during the French Revolution and Napoleonic Wars (1793–1815) that up to 8,000 prisoners from all over the world were held here. Prisoners with different nationalities were kept apart to avoid conflict. The French were held in the outer bailey, the Spanish in the north-east corner of the inner bailey and the Dutch in the keep. Americans, Danes, Germans, Italians and Lascars were also confined here.

In 1796 ships carrying 2,500 black or mixed-race prisoners of war from the Caribbean were detained at Portchester Castle. When extra capacity to accommodate prisoner numbers was needed, two prison ships or hulks, the *Captivity* and the *Vigilant*, were moored near Portchester, and in 1797 five more ships were commissioned, eventually increasing to ten. Described as 'floating tombs' by French Naval architect, Captain Charles Dupin, each hulk held around 850 prisoners. Rations were the same as those eaten in the castle, but due to overcrowding on the hulks, epidemics such as typhus and dysentery spread quickly, resulting in additional hulks being requisitioned for use as hospitals and places of convalescence for prisoners.

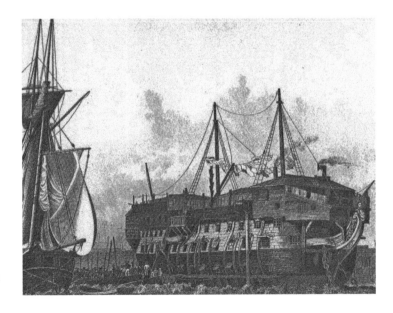

A typical prison hulk of the period.

Not all prisoners were held in hulks or in prisons. Some French and Spanish prisoners were held within the walls of Southampton, and other towns in the county. Officers who gave their word to abide by parole conditions and not to escape lived in towns and villages and were paid twice a week to help pay for their accommodation and food. Some also received money from home and even had their families and servants living with them while waiting to be exchanged for British soldiers and sailors.

The graves of five French prisoners can be seen at St John the Baptist Church, Alresford, among them the first French prisoner to die on parole. In 1757 there were 300 French prisoners in Alresford. Occasionally Spanish prisoners were held there too. In 1779, the captain and officers of a Spanish man-of-war held a ball in gratitude for the polite and generous treatment they received while on parole.

Odiham also housed French prisoners on parole and the graves of two French prisoner lie in All Saints' Church, close to Frenchman's Oak, an ancient tree on London Road that marked the boundary limit of the prisoner's parole. Other designated parole towns included Bishop's Waltham, Hambledon, Andover and Petersfield.

The King's House, Winchester, served as a prison during the Seven Years' War for 5,000 French soldiers, and again during the American War of Independence from 1778 to 1785. During the war with America in 1812 many American prisoners were held in hulks, prisons and other buildings across Hampshire, including Forton gaol and barracks.

French POW graves, St John the Baptist Church, Arlysford.

Forton Barracks. (LM)

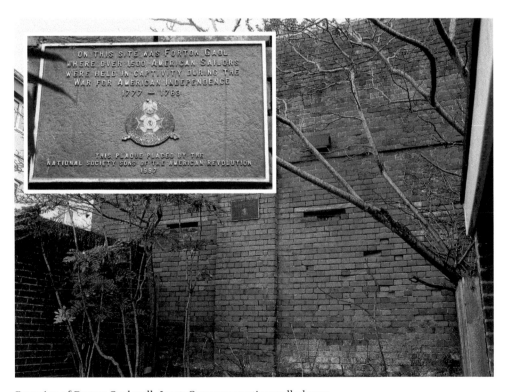

ON THIS SITE WAS FORTON GAOL
WHERE OVER 1500 AMERICAN SAILORS
WERE HELD IN CAPTIVITY DURING THE
WAR FOR AMERICAN INDEPENDENCE
1777 — 1783

THIS PLAQUE PLACED BY THE
NATIONAL SOCIETY SONS OF THE AMERICAN REVOLUTION
1997

Remains of Forton Gaol wall. *Inset*: Commemorative wall plaque.

Prisoners were kept at Portchester Castle until the Peace of Amiens was signed in 1802. Although war broke out again in 1803, the castle became a barracks and ordnance store until 1810, becoming a prison depot again until the war ended in 1814. It then became a prison for military deserters until 1819. During the eighteenth century French and later American prisoners were also imprisoned at Fortune Hospital, Gosport. Escapes were common and on one occasion fifty-seven Americans tunnelled out, disappearing into the countryside.

The First and Second World Wars created unprecedented demands for new POW and internment camps across Britain. Throughout Hampshire various camps and satellite sites were built to house German and then Italian prisoners and civilian nationals. Gosport was the site of an internment camp for 3,600 people during the First World War.

During the Second World War, twenty-one POW camps were created across the county. At Romsey, Ganger Camp No. 41 was used first for Italian prisoners and later for German prisoners, who stayed there until 1947. After this the camp provided temporary housing for Romsey and Stockbridge Council until the 1960s, when they replaced the huts with council housing. Prisoner of War Camp No. 65, on Setley Plain, was also built to hold Italian POWs. In 1944 the camp held German prisoners until 1947, when the New Forest Rural District Council used it to house families of returning servicemen there. The camp remained until enough council housing had been built, then it was destroyed during the 1950s.

For centuries, makeshift buildings, holes in the ground and civilian prisons had been used to imprison servicemen. To avoid mixing soldiers with criminals, in 1844 the Army introduced the first military prisons for personnel breeching military regulations. While most camps had detention barracks for prisoners sentenced to less than seven days incarceration, longer sentences were served at Southsea Castle, or at converted barracks at Portsmouth and Gosport.

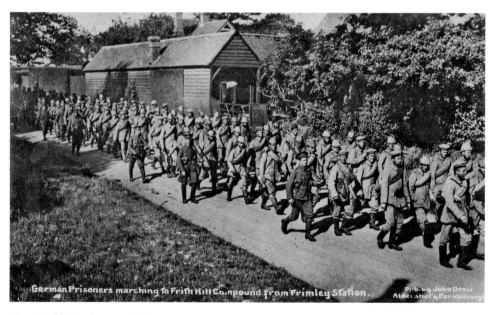

First World War German POWs.

Ganger Camp, Woodley, Romsey. (MK)

Concrete dwellings at Ganger Camp, now Nos 23–29 Woodley Close. (GC)

By 1855 Hampshire's only army prison was at Aldershot, a wooden building with tall brick outer walls. It was rebuilt in brick in 1870, becoming a large building with a huge glass lantern roof from which it derived its nickname, 'the Glass House', a term now synonymous with all military prisons. Although run by the Army, the prison also accommodated Royal Flying Corps and then Royal Air Force personnel. In 1946 inmates rioted over rations and conditions, setting fire to the building and destroying it. Demolished in 1970, it was rebuilt to resemble a Victorian prison.

Naval offenders in Hampshire originally went to Winchester Gaol. The Admiralty, like the Army, wanted an alternative way to house sailors other than alongside criminals. Two naval prisons were built during the 1850s – one in Lewis, Sussex, the other in Bodmin Gaol, Devon. In the early 1900s these were replaced by three Detention Quarters (DQs) or 'Deeks', at Chatham, Davenport and Portsmouth. Opened in 1911, Portsmouth's DQ, known as the Dockside Hotel was in the old Convicts' Prison by Anchor Gate. In 1931 the DQs were reduced to one, with all detainees being transferred to Portsmouth. It closed its doors in 1995, moving to the Tri Service Military Correction Centre at Colchester and is now home to the Royal Marine Band.

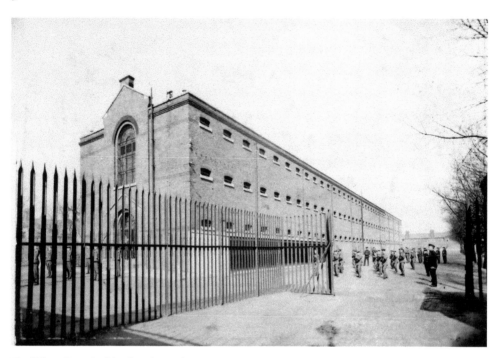

The 'Glass House', Aldershot. (AMM)

Inside the 'Glass House'. (AMM)

6. Hospitals and Cemeteries

The Royal Naval Hospital Haslar was Britain's foremost military hospital, giving medical care to the Royal Navy, its marines and merchant services for 250 years, and more recently to all three services and civilians. Built with local clay bricks and only half completed, it opened in 1754. Once finished it was the biggest brick building in Europe, and the largest hospital in England. Built upon an island, patients arrived by boat until a bridge was built over Haslar Creek in 1795, providing a direct link to Gosport. Enclosed by high brick walls and railings, its design and location were chosen to prevent press-ganged sailors from absconding.

Wounded and sick sailors and soldiers from many nationalities – allies and enemies alike – were treated at Haslar from conflicts around the world, including Trafalgar, Corunna, Waterloo, the Crimean, the Zulu, and Boer wars, both world wars and the Falklands War. Many famous physicians, surgeons and naval personalities served at Haslar including James Lind, the father of nautical medicine, who discovered a cure for scurvy; Artic explorer and Naval hydrographer Admiral Sir Edward Parry, who improved working relationships and conditions for both staff and patients while he was there; explorer and naturalist William Balfour Baikie, who discovered a treatment for Malaria; and Edward Atkinson vaccinator and Antarctic explorer, who found the remains of Scott's ill-fated South Pole expedition of 1912, and later fought at Gallipoli where he was highly decorated for his life-saving actions.

Haslar Hospital, 1783. (HHG)

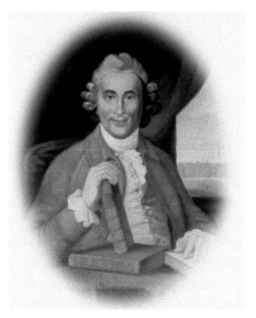

Left: James Lind. (HHG)

Right: Admiral Sir Edward Parry. (HHG)

During the 1940s, the country's first blood bank was set up at Haslar and throughout the Allied invasion of Normandy and afterwards, Royal Navy surgeons were joined by US Army surgeons treating numbers of troops from both sides. In 1966 Haslar changed from a Naval hospital to a Tri-Service hospital. Over the centuries many unsung heroes have served at Haslar including members of the Queen Alexandra's Royal Naval Nursing Service, the Voluntary Aid Detachment, Wren Sick-Berth staff, Royal Navy Medical Branch staff, and in later years medical colleagues from the Army and Royal Air Force.

Until 1826 the hospital had no burial provision, so the dead were buried in unconsecrated ground in a paddock to the south-west of the hospital, one of the densest areas of burials in the UK; tens of thousands of service personnel are buried there. Having established a cemetery in the hospital grounds, it closed in 1859 when the demand for space led to the purchase of a new site at nearby Clayhall. So frequent were funeral processions from Haslar to the Clayhall Royal Naval Cemetery that the route was nicknamed 'Dead Man's Lane'. However, for fear of upsetting patients the band could not play the funeral march until they entered Clayhall Road.

Clayhall holds many fine memorials commemorating the brave deeds and tragic circumstances in which many personnel lost their lives. Among them is a mass grave of forty-two sailors from HM Submarine L55, which sunk in the Baltic Sea on 9 June 1919. In 1928 the Russian Navy raised the vessel and returned the crew for burial. The Russians used the sub, but it sank again losing all hands. Over 1,500 British Sailors are remembered at Clayhall and within part of the cemetery is an area holding the graves of twenty-six Turkish sailors who between 1850 and 1851 died from cholera while in port.

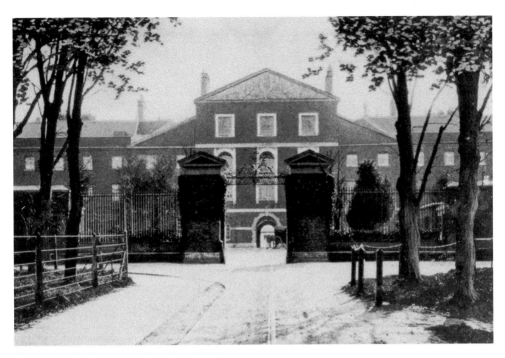

Entrance to Haslar Hospital, *c.* 1880. (HHG)

HM L55 Monument.

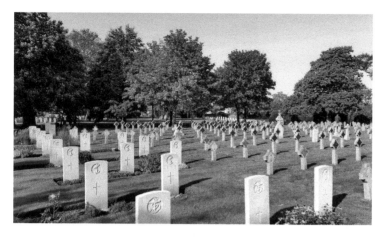

Clayhall Royal Naval
Cemetery. (HHG)

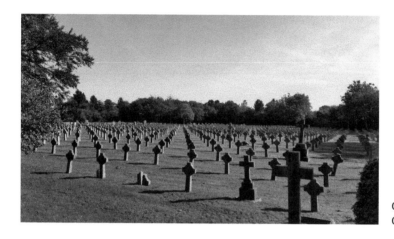

Clayhall Royal Naval
Cemetery. (HHG)

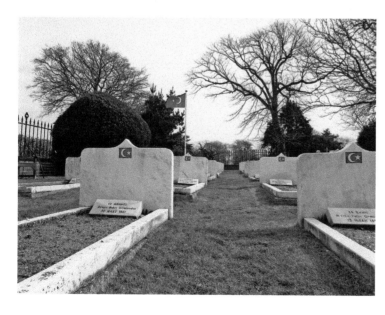

Turkish Cemetery,
Clayhall Royal Naval
Cemetery.

In 1856 Queen Victoria laid the foundation stone for the Royal Victoria Military Hospital at Netley, Southampton. Eventually dubbed the 'Palace of Pain', it was the Army's first military hospital and built in response to the high number of ill and injured soldiers returning from the Crimean War. A quarter of a mile long, it was the largest building in England, as big as a town with its own gasworks, bakery, reservoir, stables, a 170-metre pier and a prison. At that time it was the largest military hospital ever built, but although grand and attractive, its design was neither convenient nor practical. Corridors sited on the sea-facing front meant wards faced the inner courtyard; consequently light and ventilation were poor and unpleasant smells lingered throughout the building.

Being near the port of Southampton, the hospital received injured soldiers from across the empire. Having arrived at Southampton they were transferred to Netley by boat, and later by train. Both physical and psychiatric conditions were treated, and the first official Army asylum was opened here in 1870. Florence Nightingale founded a training school for military nurses at the hospital, which also became the home of the Army Medical School. Trainees were sent overseas to treat the wounded in war zones and in 1879, six nurses, known as Netleys, were sent to the Zulu War.

In 1914, a separate Welsh Hospital was set up in the north of the grounds to treat military personnel from Wales. Throughout the war trains would bring wounded from the Front to Netley Hospital three times a day. It was here during this time that staff pioneered treatment for shell shock and among those treated was the poet Wilfred Owen.

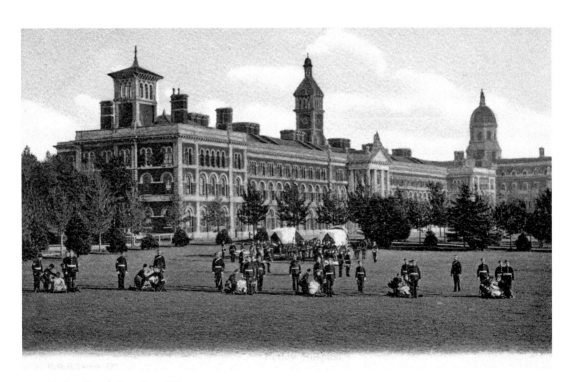

Netley Hospital, *c.* 1897. (JG)

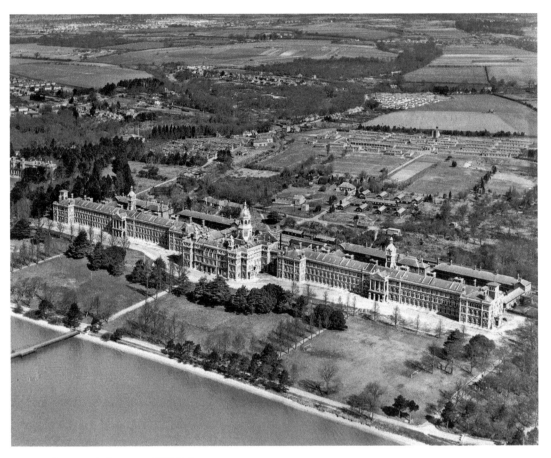

Netley Hospital, *c.* 1950. (NHHG)

It was a major base for military nurses of the Queen Alexandra Imperial Military Nursing Service (QAIMNS), QAIMNS Reserve, Voluntary Aid Detachments and the Territorial Army Nursing Service. During the Second World War, in addition to home front and general war casualties, hundreds of servicemen from Dunkirk and D-Day were treated along with POWs.

Closed to patients in the late 1950s, Netley was demolished in 1966 to make way for a country park. All that remain are the officers' mess (now private flats), the tower and a few asylum buildings.

Those who died in the hospital were buried nearby in Netley Military Cemetery, which was created in 1864. Today the cemetery lies within the grounds of the Royal Victoria Country Park, on the site of the former hospital.

The cemetery holds 637 First World War burials and thirty-five Second World War burials. Among the Commonwealth graves are forty-two Canadians, forty-nine Australians, twelve New Zealanders, six South Africans and five Indians. Additionally, there are the graves of twelve Belgians, one Polish soldier and sixty-nine German graves dating from the First World War.

The tower of Netley Hospital. (JG)

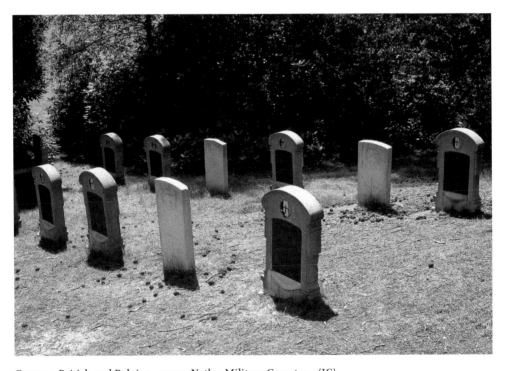

German, British and Belgian graves, Netley Military Cemetery. (JG)

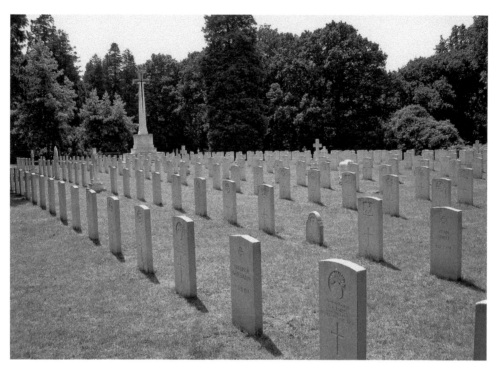

Allied soldiers' graves, Netley Military Cemetery. (JG)

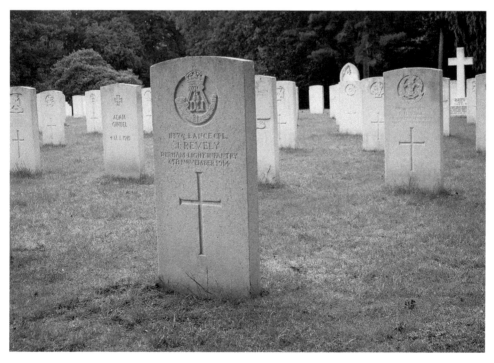

Allied and Axis graves. (JG)

German and Belgium graves. (JG)

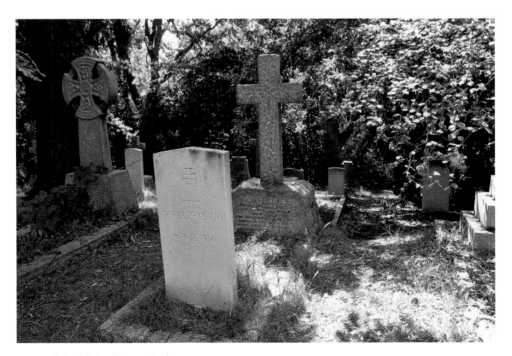

Unusual double headstone. (JG)

The principal designer of Aldershot's Cambridge Military Hospital at Aldershot was Florence Nightingale, who, in line with clinical thinking of the day, sited it upon a hill allowing the wind to sweep away any infection. Architects created tall ceilings, high sash windows, long open corridors and ventilation systems. Opened in 1879, it was the foremost medical institution caring for soldiers from the Boer Wars.

The first hospital in the UK to receive battle casualties direct from the frontline during the First World War. It was also the place where surgeon Captain Harold Gillies pioneered and set up the first plastic surgery unit in Britain.

After the Second World War, the Cambridge Military Hospital pioneered the supply of portable operating theatres and supplies for frontline duties. The hospital also housed the Army Chest Unit and casualties from the First Gulf War were treated here. However, with the decline of the country's military commitments following the Second World War, the hospital began admitting civilians and by 1996 excessive running costs and the discovery of asbestos resulted in its closure. Following the removal of asbestos and significant repairs, the hospital is currently being converted into private housing.

Built upon two hills, the military cemetery at Aldershot is unlike any other military cemetery in the world. The site holds the remains of over 17,000 military and civilian personnel, an icon and legacy to the town's military heritage and an exceptional source of social and military history. Built following the arrival of the Army in 1853, it has seen mass burials and exhumations and the funerals of many renowned military personalities, including, Samuel Cody, father of British aviation, Victoria Cross recipients, Field Marshal Sir Henry Evelyn Wood, Major William Davidson Bissett, Sergeant Ian John McKay and First World War flying ace Captain Henry Biziou.

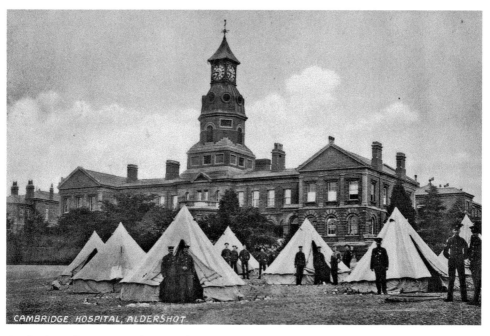

Cambridge Military Hospital, c. 1910. (AMM)

Howard Gilles. (AMSM)

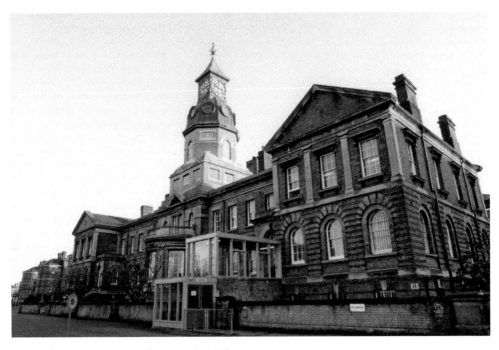

Cambridge Military Hospital, *c.* 1987. (AMM)

The chapel, Aldershot Military Cemetery. (MP)

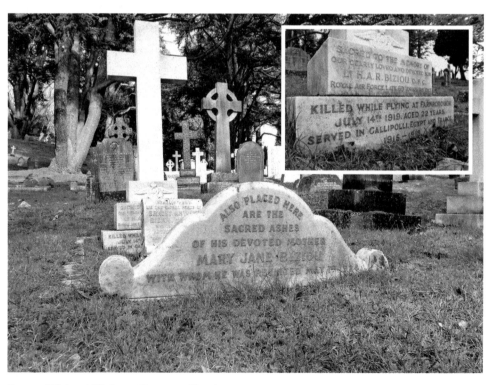

Grave of Flying ACE. *Inset*: Close-up of headstone.

Other unsung heroes and distinguished persons also rest here, such as Mrs Louisa Daniell, founder of the Aldershot Soldiers' Home and Institute, her daughter Georgiana Daniell, and Kate Hanson, who dedicated their lives to caring for soldiers in Aldershot – as well as medical personnel who died while trying to save the lives of others at the hospital and personnel who died committing acts of bravery across the garrison. Those resting here come from all walks of life and among their number include inventors, explorers, pioneers, sportsmen, lords and ladies.

At rest are personnel who fought and survived the Charge of the Light Brigade, Rorke's Drift, the Relief of Ladysmith, and the Sinwaho and Sindhora Indian Mutiny. In addition, there are casualties from modern engagements such as the First World War, the Second World War, the Anglo-Irish war, Northern Ireland, the Falklands War and Afghanistan.

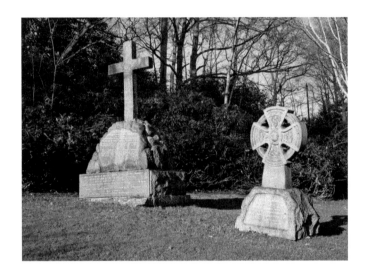

Grave markers of Mrs Daniell, Miss Georgiana Daniell and Miss Hanson.

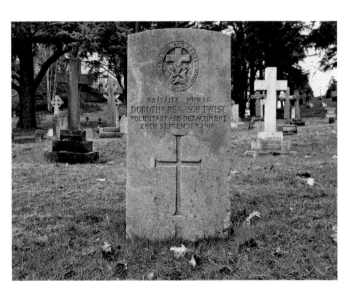

Dorothy Pearson Twist, Canadian nurse who died in service.

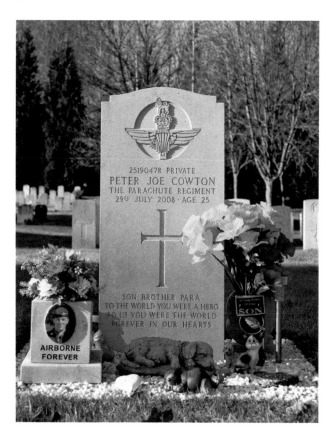

25190478 PRIVATE
PETER JOE COWTON
THE PARACHUTE REGIMENT
29TH JULY 2008 · AGE 25

SON BROTHER PARA
TO THE WORLD YOU WERE A HERO
TO US YOU WERE THE WORLD
FOREVER IN OUR HEARTS

AIRBORNE
FOREVER

Left: Private Peter Joe Cowton killed in Afghanistan.

Below: Paratroopers killed in the Falklands being repatriated.

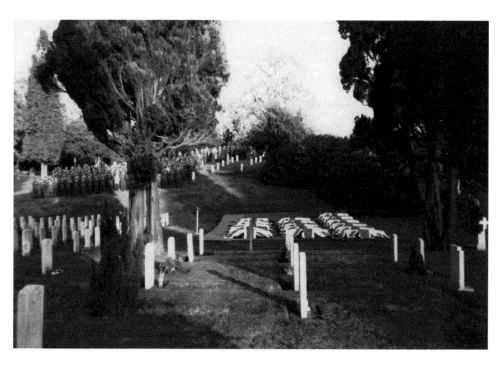

Allied and Commonwealth personnel from Russia, Holland, France, South Africa, Poland, Belgian, New Zealand and Canada serving in the First and Second World Wars are buried here, along with POWs from Germany and Italy. More recently soldiers from Nigeria and Nepal have been buried here. The variety and quality of monuments and headstones in the cemetery encapsulate the diverse and unique tri-service nature of Hampshire's military heritage.

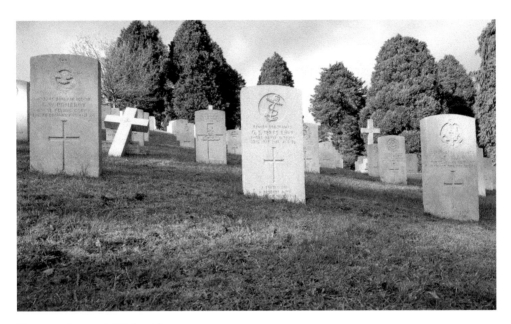

Three services rest side by side.

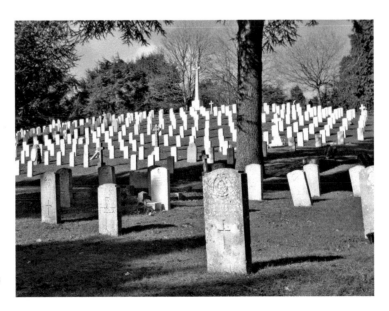

One of the cemetery's two hills.

7. Portsmouth and Southampton

Portsmouth

Portsmouth has been the centre of the UK's military shipbuilding industry for over 800 years and is the oldest Royal Navy base in in the country. The spiritual home of the Royal Navy, the city's rich naval heritage is evidenced by its many museums, monuments, memorials, fortifications and artefacts.

In AD 43 it was home to the Classis Britannica, a Roman fleet of galleys that operated out of the port to defend southern Britain from pirates and Saxon raiders. Britain's first navy, built by King Alfred the Great in AD 897, defended the harbour against Danish invaders. From the twelfth century to modern times, Britain's armies have sailed from Portsmouth to make war and conquer foreign territories. In 1194, Richard the Lionheart awarded Portsmouth a charter and gave orders to build the first dock. At Portsmouth in 1294, Sir William Leybourne was appointed Captain of the King's Sailors and Mariners and head of the first Channel squadron by Edward I (Longshanks).

In 1495 Henry VII built the world's first dry dock in Portsmouth establishing it as a major naval base and the centre of construction for all royal ships. Henry VIII's flagship *Mary Rose* was built here in 1509. It was first ship to have gun ports on the broadside, and sank in the Solent in 1545. In 1982 she was found and raised. Her preserved remains, along with 19,000 artefacts, are now on display in the Mary Rose Museum, the only such warship on display in the world.

Lord Horatio Nelson, hero and protector of the English people, was a prominent figure in Portsmouth. It was here, prior to sailing to Trafalgar in 1805, that he took his last walk on English soil. As was custom for captains, he stayed at the George Hotel in Old Portsmouth. Following news of his arrival well-wishers flooded the town wanting to bid him farewell. To avoid the gathering crowds, he left via the back door and walked towards the Garrison Church to join HMS *Victory*. The crowds, realising he had left, flocked to the seafront and found him waiting on the beach for a rowboat. With the cheers of the crowds resounding across the water, Nelson waved his hat to them and, turning to Hardy, whispered. 'I had their huzzas before, I have their hearts now!' He sailed off to glory, adding Trafalgar to his earlier victories at the Nile and Copenhagen – but at the cost of his life. The route is now signed with information markers and enables visitors to follow in his footsteps.

In 1922 HMS *Victory* the oldest commissioned warship in the world, entered Portsmouth dry dock No. 2 where she was restored. After surviving a demolition order, the ravages of teredo worm, death watch beetle and German bombing raids during the Second World War, she now rests in Portsmouth's historic dockyard. Guided and self-guided tours of the *Victory* are available and areas of interest including where Nelson fell and the surgeon's cabin where he died can be viewed. Apart from the ship herself, the largest single artefact to survive the Battle of Trafalgar is *Victory*'s original top sail, now displayed in Storehouse No. 10.

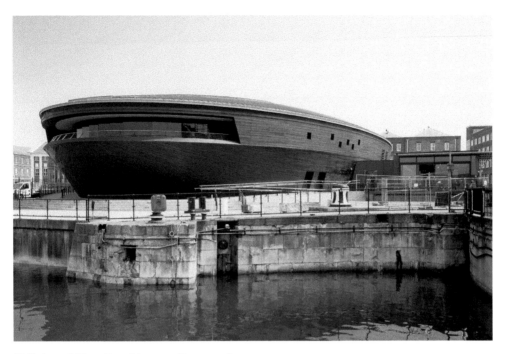

Hull-shaped Mary Rose Museum, Portsmouth.

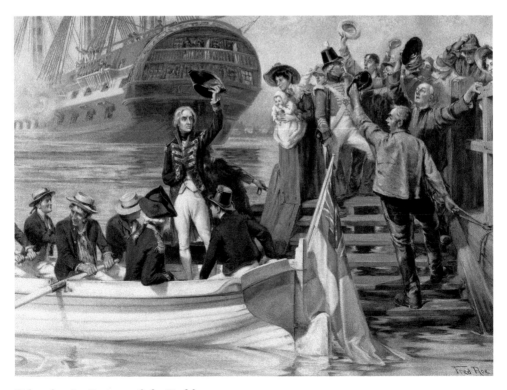

Nelson leaving Portsmouth for Trafalgar.

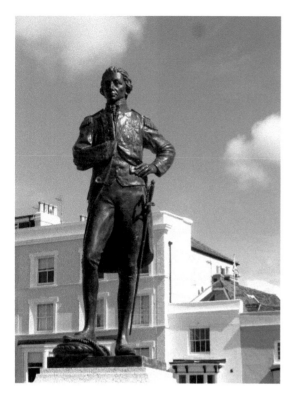

Left: Memorial statue of Nelson, Portsmouth.

Below: HMS *Victory*, Portsmouth.

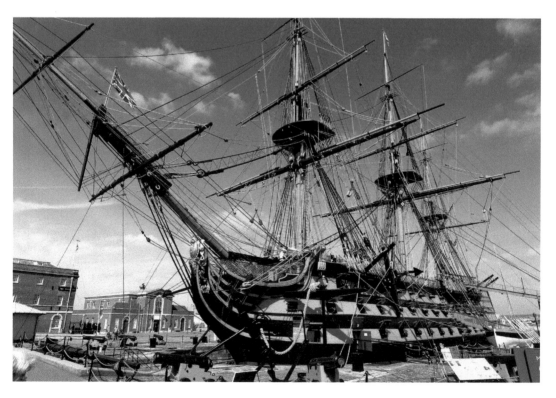

By 1850 Portsmouth was the largest industrial site in the world and HMS *Inflexible*, then the world's biggest battleship and first to be fitted with electric lighting, was launched from there in 1876.

The first two British submarines, *Holland I* and *Holland II*, arrived at Portsmouth in 1902 along with their support ship HMS *Hazard*, creating Britain's first submarine flotilla. *Holland I* sank in 1913 but was located and raised in 1982. It is now on show at the Gosport Submarine Museum, along with many exhibits that preserve the heritage of Portsmouth's training facilities in the use of submarines and torpedo testing.

In 1506 Edward VII launched the revolutionary big-gun ship HMS *Dreadnought*, followed in 1913 by the first oil-fired battleship, HMS *Queen Elizabeth*. Housed in dry dock No. 1 alongside HMS *Victory*, is HMS *M33*, which was built in 1915 as a floating gun platform and saw service during the British landings at Suvla at Gallipoli in 1915. It is the last remaining British ship from the Dardanelles campaign (1915–16) and the Russian Civil War (1917–22).

Portsmouth Harbour is also home to HMS *Warrior*, Britain's first ironclad warship. Launched in 1860, she was the pride of the Victorian Black Battlefleet. Powered by steam and sail, she was the largest, fastest and most powerful warship of her day and had a lasting influence on naval architecture and design. Built to counter the latest French battleship, *Warrior* was considered the ultimate deterrent. However, after only twenty-two years' service advances in technology resulted in her becoming outdated. Her hull was

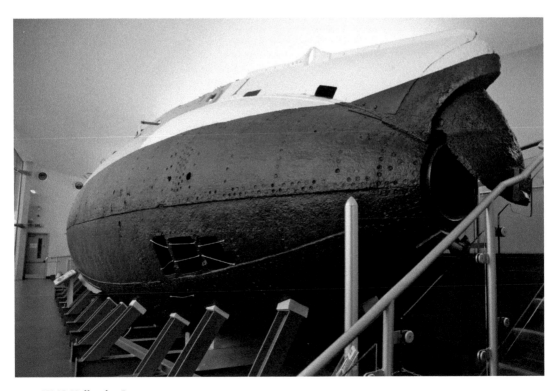

HMS *Holland 1*, Gosport.

HMS M33, Portsmouth.

used as a depot, floating school and an oil jetty, before being restored and returned to Portsmouth in 1987. A unique survivor of a bygone age, she now serves as a museum ship and visitor attraction.

The dockyard has undergone many transformations with new docks, boathouses, storehouses, rope houses and other specialist buildings added as the Navy expanded and technology advanced. Founded in 1911, the Royal Naval Museum is located among a number of historic buildings within the dockyard and is one of the oldest maritime museums in the country.

During 2018 another heritage attraction will join the Historic Dockyard in the shape of the Royal Marines Museum. Previously situated in the officers' and marines' quarters of Eastney Barracks, the museum charts the history of the Royal Marines and their association with Portsmouth. When it moves to the Historic Dockyard the museum will become private apartments, with the original exterior of the building remaining unchanged.

Created as part of the defences of Portsmouth Harbour in 1756, Priddy's Hard dockyard, became the Royal Navy Gunpowder and Munitions Depot. During the Napoleonic Wars the complex was extended. In 1848 a laboratory was added for testing the quality and condition of gunpowder and the site was later adapted to meet the evolving technological needs of naval ordnance and to improve security against sea-bound and land-bound attack.

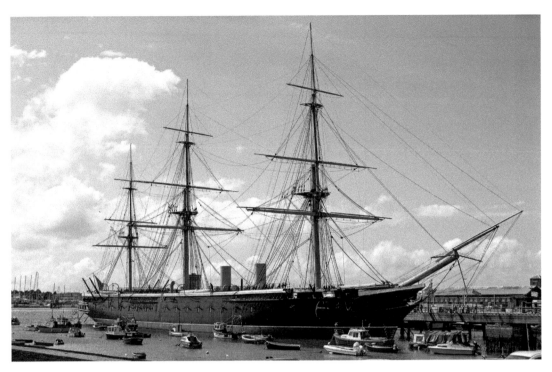

HMS *Warrior*, Portsmouth.

During the Second World War 2,500 women filled jobs vacated by men on active service. The dockyards noteworthy naval activity occurred in 1982 during the Falklands War. It is now home to the Naval Fire Powers Explosion Museum, which tells the story of naval warfare from gunpowder to modern missiles.

Besides its monuments and museums, Portsmouth is famous for keeping its military legacy alive through festivals, commemorations and re-enactments. For 100 years the Royal Navy took part in the Royal Tournament's Field Gun display, which honoured the extreme strength, determination and fitness shown by the men of the Bluejackets, who in 1899, after a gun carriage collapsed during the Ladysmith campaign, carried the gun across country, over 2 miles to the top of a hill and into action.

To commemorate this, a competition was established between naval personnel at Portsmouth, Chatham and Devonport. The Portsmouth Field Gun Team trained publicly and practised their gun runs on Whale Island. From 1907, teams competed annually at Olympia at the Royal Tournament; however, the tournament ended in 1999, 100 years after the Battle of Ladysmith. Entitled 'The Final Chapter', the last ever Gun Run took place between Portsmouth and the Fleet Air Arm, and contrary to their orders members wore black arm bands. At the end both when teams gathered in the centre of the arena to receive a standing ovation, Portsmouth unfolded a banner offering their thanks for the years of support that read 'The final chapter, goodbye Portsmouth Field Gun'. However, its legacy continues through the Royal Navy Field Gun Tournament, held annually at HMS *Collingwood* in Fareham, Hampshire.

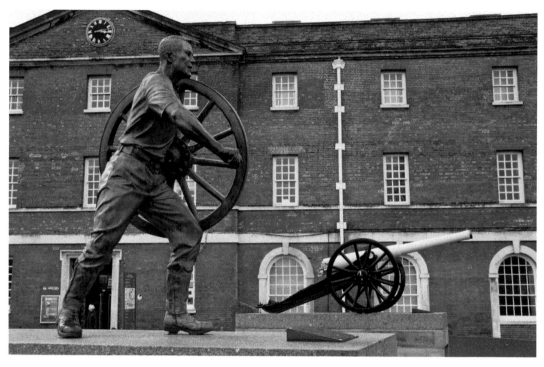

Statue and field gun commemorating the field gun competition.

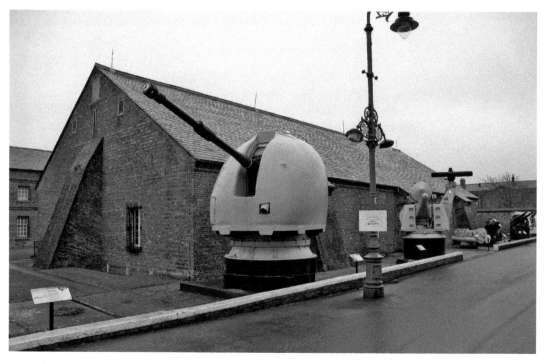

The Naval Fire Power Museum, Gosport.

In acknowledgement of the naval tradition of mast climbing, and in recognition of the strength and courage needed by sailors who climbed the rigging to fix ships sails. The Royal Navy Sailors Mast Manning Display Team climbed up a tall mast on shore to synchronised music. Portsmouth has hosted the mast manning team many times in the city, with the last display being held in 1995. The second display was the Window Ladder, which was frequently seen at Gala events in Portsmouth it was regularly performed by Sea Cadets at the Royal Navy Field Gun Tournament. Cadets climbed up a square lattice work of ropes to music, assembling and dismantling the framework as they went.

Southampton

Since Roman times Southampton has been at the heart of Britain's maritime history. Alfred the Great built Britain's first navy there and over time the port and town have become an important hub for trade and commerce and a gateway to travel. With its mediaeval walls, Bargate, museums and monuments, Southampton's military heritage is every bit as diverse and interesting as neighbouring Portsmouth. God's House Tower on the corner of the Town Quay, and Lower Canal Walk, was constructed in 1417 following French raids eighty years earlier and were part of the first dedicated artillery fortifications built in England.

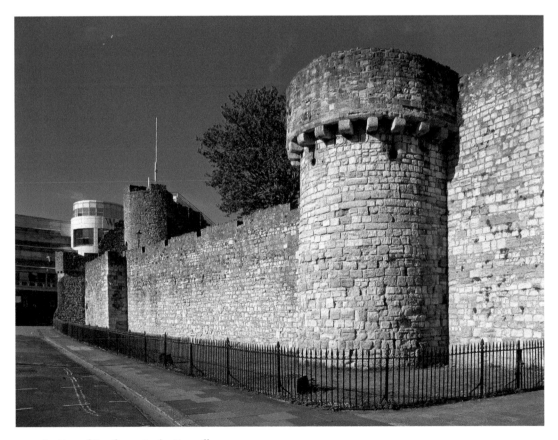

Section of Southampton's city walls.

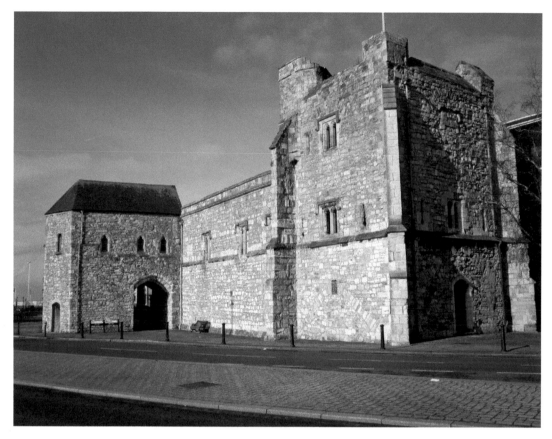

God's House Tower, Southampton.

The legendary military hero Major General Charles Gordon – known severally as Chinese Gordon, Gordon Pasha and Gordon of Khartoum – is remembered in the Queen's Park where a memorial to him stands in the shape of a Corinthian column topped with a cross. Gordon lived in Southampton and fought bravely in the Crimean War and the Second Opium War. He famously reorganised China's 'Ever Victorious Army', leading it to a series of thirty-three successive victories during the Taiping Rebellion. Before the Mahdi's revolt in 1885, as Governor-General of the Sudan, he evacuated 2,600 civilians and soldiers from Khartoum before being killed during the uprising. Gordon is also commemorated in the Gordon family's tomb located in Southampton's Old Cemetery.

One of the town's more unusual military connections is to the war horse Warrior, whose grave is located at the edge of the golf course at Southampton Sports Centre. The grave is marked by a granite memorial stone surrounded by a horseshoe shaped flower bed. Warrior served in France with the Old Contemptibles throughout the First World War. He took part in the retreat from Mons and was wounded in the advance to the Aisne. After the war he was presented to the town of Southampton and saw service with the police until his death aged twenty-six in 1935.

General Gordon's Monument,
Southampton.

Monument to the War Horse Warrior,
Southampton.

Like Priddy's Hard, the Royal Naval Armaments Depot, was developed on Southampton Water during the nineteenth century for the storage and management of gunpowder, and later for the storage of other munitions. Following Napoleon's invasion of Russia in 1812 the Inspector General of Fortifications ordered a store for 20,000 barrels of gunpowder to be built at Marchwood. By 1814, three magazines and examining rooms had been constructed, linked by a system of canals. Each building was protected by high-walled enclosures, earth banks and blast walls. An office, guard house and a barrack block were erected nearby in Magazine Lane. After being closed in 1850 the depot reopened during the outbreak of the Crimean War and between 1856 and 1857 four larger magazines were added, although air-raid damage destroyed several of the magazines in 1940 – it was decommissioned after the war. A rare example of military works constructed during the Napoleonic Wars, the site remains of local and national importance.

The Supermarine Spitfire remains the most iconic fighter aircraft to grace the skies of Britain. It was designed and constructed at Southampton by aeronautical engineer R. J. Mitchell, the chief designer at Supermarine Aviation. In 1936, the first Spitfire flew from Eastleigh, today's Southampton Airport. The only British fighter to be manufactured before, during and after the Second World War, 23,000 Spitfires were produced. Designed as a short-range plane to defend Britain from bomber attack, the Spitfire achieved legendary status during the Battle of Britain.

R. J. Mitchell.

Home of R. J. Mitchell, Portswood, Southampton. *Inset*: Commemorative plaque.

In August 1940, in the skies above Southampton, Flying Officer James Brindley Nicolson won the only Victoria Cross awarded to RAF Fighter Command during the Second World War. His citation reads:

> During an engagement with the enemy near Southampton on 16th August 1940, Flight Lieutenant Nicolson's aircraft was hit by four cannon shells, two of which wounded him whilst another set fire to the gravity tank. When about to abandon his aircraft owing to flames in the cockpit, he sighted an enemy fighter.
>
> This he attacked and shot down, although as a result of staying in his burning aircraft he sustained serious burns to his hands, face, neck and legs.
>
> Flight Lieutenant Nicolson has always displayed great enthusiasm for air fighting and this incident shows that he possesses courage and determination of a high order.
>
> By continuing to engage the enemy after he had been wounded and his aircraft set on fire, he displayed exceptional gallantry and disregard for the safety of his own life.

8. Aldershot and Farnborough

Aldershot

In 1854 the War Department bought 8,000 acres of heathland near the village of Aldershot to establish a permanent training camp for the Army. It soon became known as the home of the British Army, and by 1856 two encampments of wooden huts had been built on either side of the Basingstoke Canal.

The North and South Camps accommodated 20,000 men, mainly militia, while permanent brick barracks for regular troops were built further south. These became the Wellington Lines, in honour of the Duke of Wellington, and were formed by three infantry barracks – Badajos, Salamanca and Talavera – three cavalry barracks – Beaumont, Willems and Warburg – and two artillery barracks – Waterloo East and West.

Aldershot: proud of its heritage.

As the camp grew new lines were added: Stanhope (later renamed Montgomery) and Marlborough. During the 1960s many military buildings were demolished and replaced by new barracks and married quarters, which have since been redeveloped to provide private housing. Although most of the original brick-built barracks and buildings from the 1850s to the 1890s no longer exist, remnants of Aldershot's rich military heritage remain.

Beaumont, Willems and Warburg Barracks were built to house the 1st Cavalry Brigade. Each included a large riding school building, four parallel three-storey barrack blocks with stables on the ground floor. During the 1970s Beaumont barracks was replaced by private housing, although the riding school, main gateway and flanking guard houses still exist. Willems and Warburg were replaced by supermarkets, private housing and a leisure development. In the case of Williems only the original gateway to Willem Barracks has survived. Nothing remains of the original infantry and artillery barracks.

Within the grounds of the Aldershot Military Museum are four historic buildings that now serve as galleries. The last two Victorian brick-built barracks in Aldershot tell the story of the military town from 1854 to the present day. Field Marshal Montgomery's barn, built following the Second World War to house his command caravans, shows advancements in military transportation, while the Boyce Building, moved to the site from Queen Elizabeth Barracks, Church Crookham, in 2006, is a fine example of an early wooden barracks and houses a small gallery telling the history of the corps based there.

Cavalry gate of Williams Barracks, Aldershot.

Victorian barracks, now Aldershot Military Museum.

Field Marshall Montgomery's barn.

Nearby in Queens Avenue is the former site of the first Army gymnasium built in 1866, together with the Army School of Physical Training, the Fox Gymnasium built in 1894 and the military swimming baths dating from 1900.

Within the school is the Royal Army Physical Training Corps Museum, which relates the story of physical training in the British Army from 1860 to the present day. Nearby are the impressive South-East District Headquarters Building of 1894 and Smith-Dorrien House built in 1908 to give soldiers access to wider opportunities for entertainment, companionship, reading, studying and playing games. Next to Smith Dorrien House towards the top of Queen's Avenue is Maida Gym, a former Army boxing gymnasium, built in 1896.

The red-brick Royal Garrison Church of All Saints is a local landmark. Built in 1863 in the Gothic Revival style, it holds a variety of regimental and individual memorials. In the south-west corner of the church is the Royal Army Dental Corps Chapel and in the south porch stands a 9-foot dark wooden cross. This is a memorial to the officers and men of 1st Division based in Aldershot who were killed in action in 1916 near High Wood during the battle of the Somme. Originally erected at High Wood, it was brought back to the 1st Division Headquarters in Pennefather's Road, Aldershot. In January 1939 to prevent further deterioration, it was moved into its present location at the south porch, which was then named the 1st Division Porchway.

Fox Gym, Aldershot.

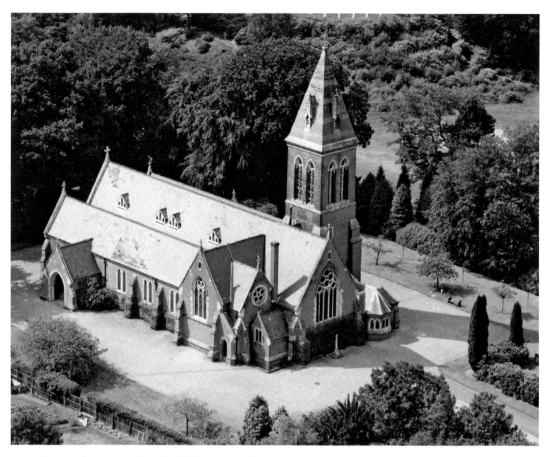

The Royal Garrison Church of All Saints, Aldershot.

The Great East Window is the largest stained-glass window in the church. Commissioned by the 37th Hampshire's, it commemorates the officers, NCOs and men of the regiment killed during the Indian Mutiny of 1857–59. Since 1967 the church has become the spiritual home of the Parachute Regiment where inside and outside are several memorials to its members. Men from the Parachute Regiment who died during the Second World War are also remembered on individual kneelers.

Instigated by Prince Albert, the Prince Consort's Library was one of the first libraries to be constructed to serve barracks. Created to play a practical role in modernising the Army and raising its training standards, it provided a resource for the professional development of military officers. It is now open to all ranks and is an important specialist military library. Prince Albert not only initiated its building but paid for the library and donated 2,000 books.

Among the many significant monuments in Aldershot are the Royal Army Medical Corps Boer War Memorial, British Army 2nd Division WWI Memorial, British Army 8th Division WWI Memorial and the Aldershot Cenotaph, and the famous equestrian statue to the Duke of Wellington.

The Prince Consort Library, Aldershot.

Farnborough

Farnborough, being close to Aldershot and the open heathland, was an obvious location for the research and development of military aviation. In 1905 the Balloon Section of the Royal Engineers and the Balloon Factory arrived at Farnborough from Aldershot. These establishments trained aeronauts and manufactured the equipment for the Army's observation ballooning units. Among them was Britain's father of flight, Samuel Franklin Cody, who was Chief Instructor of Kiting at the Balloon School. Cody experimented with his man lifting kites at Aldershot and nearby Laffan's plain. While engaged in his experimental kite work the Army allowed him to conduct research into glider kites and powered aircraft.

During 1906 the Balloon Factory's first wind tunnel was completed, and following testing in 1907 the first British airship, Army Dirigible No. 1, *Nulli Secundus*, piloted by Samuel Codey with Colonel Capper on board, successfully completed its maiden flight.

In 1908 Cody made Britain's first official sustained, controlled powered aeroplane flight in the British Army Aeroplane No. 1, travelling 496 yards in twenty-seven seconds at an altitude of between 30 and 40 feet. Today a granite block, bearing a commemorative plaque, marks the take off point of Cody's first flight. He died in August 1913 when his private machine broke up over Farnborough. In recognition of his achievements and contributions to military aviation he was buried with full military honours in Aldershot Military Cemetery. A commemorative statue erected to him stands outside Trenchard House., behind which is a pavilion housing a replica of Cody's British Army Aeroplane No. 1.

Farnborough: proud of its aviation heritage.

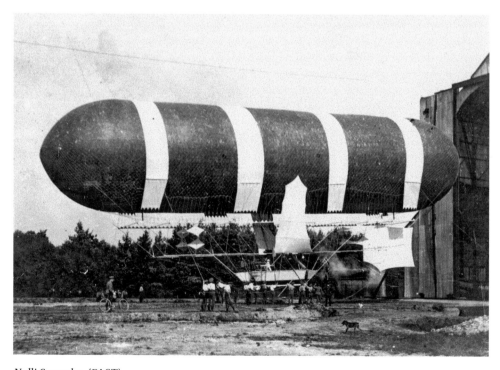

Nulli Secundus. (FAST)

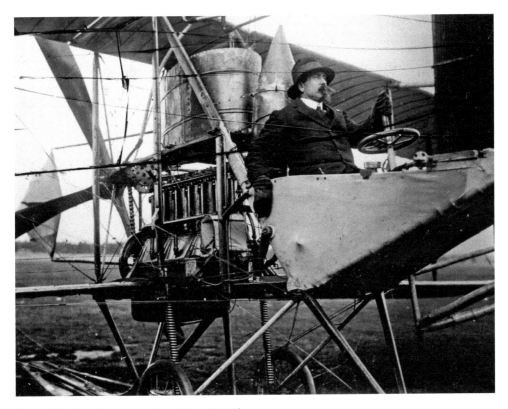

Samuel Cody in Army Aeroplane No. 1. (FAST)

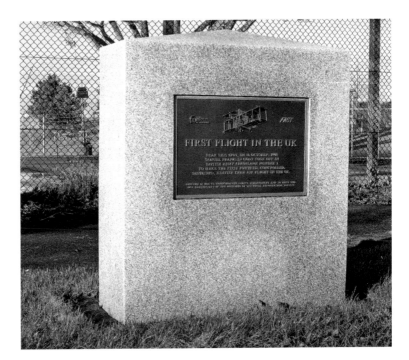

The Cody
flight marker,
Farnborough.

Following the growth in early aviation activity, the War Office issued instructions for the School of Ballooning to be expanded into a battalion and in 1911 the Air Battalion Royal Engineers was formed at Farnborough. The following year the Balloon Factory changed its name to the Royal Aircraft Factory (RAF).

Built in 1907, Trenchard House is one of the oldest aviation-related building in the country. Until 1912 it served as the headquarters of the Air Battalion Royal Engineers. Now home of the Farnborough Air Sciences Museum, it tells Farnborough's story as the birthplace of British aviation, highlighting its many connections with the military and its aeronautical research and development.

Among the many test pilots at the Royal Aircraft Factory, few were as talented as Lieutenant Edward Teshmaker Busk. A brilliant scientist and engineer, he pioneered early aircraft design regarding stability and control in flight and in 1914 designed the first inherently stable aeroplane. He was killed later that year while flying over Farnborough and is buried in Aldershot Military Cemetery, close to Cody's grave. There is a memorial sundial to him at the FAST museum overlooking the Farnborough airfield.

Another influential test piolet to be buried at Aldershot Military Cemetery was Captain Keith Lucas, a physiologist and Cambridge graduate who made significant contributions to aircraft design. These included the development of the spherical compass, which allowed the effective use of a magnetic compass in flight. When conducting his experiments at Farnborough he flew as a passenger but was convinced that his research would improve if he became a pilot. As a result, he attended a flying course at Upavon in 1916 but was killed in a mid-air collision.

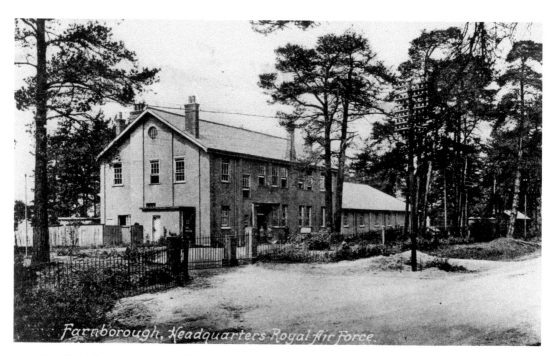

Trenchard House, *c.* 1920. (FAST)

Trenchard House today, Farnborough.

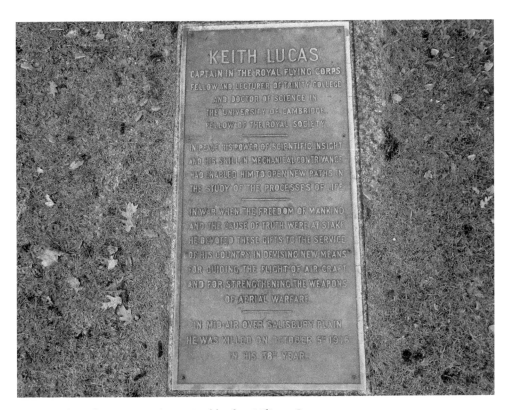

Grave marker of Captain Keith Lucas, Aldershot Military Cemetery.

St Mark's Church, built in 1880, served as the garrison church for the RFC and the early RAF during the First World War. Inside is the first memorial chapel dedicated to the RFC and a commemorative plaque to the boy entrants of the RAF School of Photography, who served and died during the Second World War.

In 1918 the Royal Air Force (RAF) succeeded the RFC and to avoid confusion the Royal Aircraft Factory was renamed the Royal Aircraft Establishment (RAE). The innovative scientists, inventors and designers of the RAE created many remarkable military inventions. Among them a young Royal Air Force engineer Frank Whittle, who would later retire as Air Commodore and be knighted for his contributions to aviation. Whittle invented the turbojet, a creative advancement in aeroplane design that revolutionised both military and civilian aviation.

The first British aircraft fitted with a Whittle W1 jet engine was the Gloster E28/39, which first flew in 1941. This led to the development of the Gloster Meteor, the first British military jet aircraft, a full-scale model of which has been erected as a memorial to Frank Whittle outside of the northern boundary of Farnborough Airfield.

During the Second World War many aviation advancements were made at Farnborough, including innovative gyro gun sights for combat aircraft, specialised reconnaissance cameras and bombsights. Of note was the Tilly Shilling, which solved the problem of engines cutting out momentarily in battle during negative gravity manoeuvres.

Memorial to Lieutenant Edward Teshmaker Busk, Farnborough.

Above: St Mark's Church, Farnborough.

Right: Air Commodore Sir Frank Whittle. (FAST)

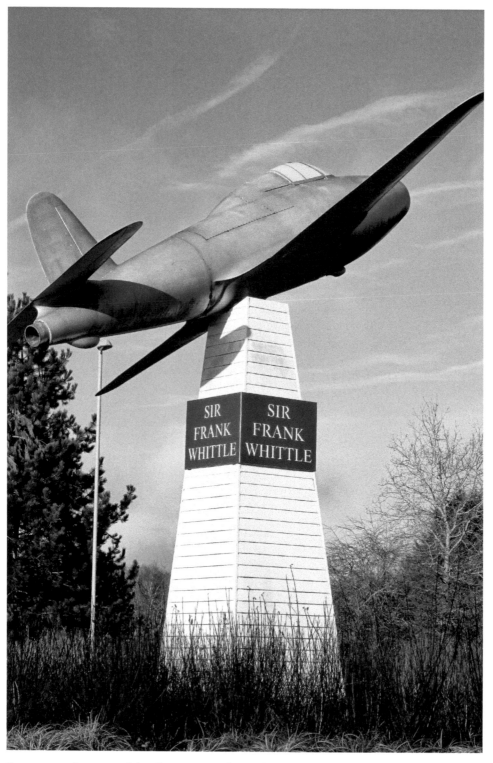

Commemorative statue of the Gloster Jet, Farnborough.

This simple but effective restrictor was created by aeronautical engineer and successful motorcycle racer Beatrice Shilling, who designed a small metal disc with a hole in the middle that fitted on the carburettor. It restricted and regulated the flow of fuel to prevent flooding, helping the RAF to match the manoeuvrability of the Luftwaffe fighters. This simple, cost-effective solution proved indispensable to the performance of fighter planes and in 1947 Miss Shilling was awarded an OBE for her work. In Farnborough there is a public house named after her honouring this achievement.

In 1988 the RAE changed its name to the Royal Aerospace Establishment (RAE) to reflect the increased breadth of its research and development. However, in 1991 the RAE ceased to exist and was renamed the Defence Research Agency (DRA), remaining an executive agency of the UK Ministry of Defence (MOD).

Hampshire's long and proud military heritage has been forged by the innovative spirit, daring imagination and the unconstrained courage of its military and civilian personnel. Home of the British Army and birthplace of the Royal Navy and British aviation, its coastline and strategic ports have repeatedly repelled attackers and were a springboard successive defences of the realm. No other county can boast a military heritage as diverse as Hampshire's, and long may that continue.

Miss Beatrice 'Tilly' Shilling at the RAE. (FAST)

The Tilly Shilling public house, Farnborough.

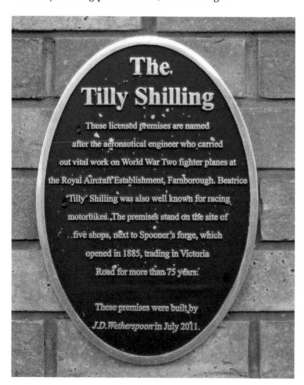

The Tilly Shilling

These licensed premises are named after the aeronautical engineer who carried out vital work on World War Two fighter planes at the Royal Aircraft Establishment, Farnborough. Beatrice 'Tilly' Shilling was also well known for racing motorbikes. The premises stand on the site of five shops, next to Spooner's forge, which opened in 1885, trading in Victoria Road for more than 75 years.

These premises were built by J.D. Wetherspoon in July 2011.

Commemorative plaque.

About the Author

Dean Hollands comes from a military family and his interest in military history spans over four decades. Having served eight years with the Royal Army Ordnance Corps in the UK, West Germany and the Falkland Islands as a supply specialist and physical training instructor, Dean joined Surrey Police. Now retired, Dean spends much of his time conducting guided battlefield tours in the UK and Europe, giving talks, undertaking research and writing about his interests. He is regularly invited to the USA to talk at the New Jersey State Association of Chiefs of Police's senior leadership programme and annually delivers bespoke leadership training at the NJSACOP's European battlefield staff ride programme.

Dean is a volunteer at the Aldershot Military Museum and became the chair of the Friends of Aldershot Military Museum in February 2018. He is also a volunteer with the Commonwealth War Graves Commission, an associate member of the Guild of Battlefield Guides and a member of the Western Front Association.

Acknowledgements

In finding the primary sources needed to research the subject of this publication I am thankful to the many wonderful and like-minded people I have met along the way. Their help, guidance and support have proved invaluable. I am thankful to Hampshire Cultural Trust, the staff of the Aldershot Military Museum, the Royal Hampshire Regiment Museum, the Farnborough Air Sciences Trust Museum, the National Museum of the Royal Navy, Hampshire History, the Gosport Society, Haslar Heritage Group, the Netley Hospital Heritage Group, the Hampshire County Council Library Services, Army Medical Services Museum and Rushmoor Writers, without whom it would not have been possible to complete this project.

For allowing the use of their images I am obliged to the Aldershot Military Museum (AMM), Farnborough Air Sciences Trust Museum (FAST), Army Medical Services Museum (AMSM), Historic England (HE), James Lancaster – CastlesFortsBattles.co.uk (JL), Tim Denton (TD), Hampshire Archaeology (HA), Welcome Images (WI), Martyn Pattison (MP), Royal Hampshire Regiment Museum – Winchester (RHR), Louis Murray – copyright 2017 (LM), Marje Kemish (MK), Geoff Connel (GK), Haslar Heritage Group (HHG), the Netley Hospital Heritage Group (NHHG), Mick Paskin (MP), Michael Coppins (MC), Daderot (DT), Hampshire Data Portal (HDP), Leonie McCamlie (LM). All other pictures are from the author's collection.

I offer special thanks for their meritorious support to Maria Hollands, Paul Vickers, Peter and Barbara Reese, Cathrine Milne, Sharon Berry, Louise Page, Jane Sleight, Helen Banham and to Leonie McCamlie for producing the original artwork.